IMAGES
of America

CHICAGO
City of Flight

Jim and Wynette Edwards

ARCADIA

Published by Arcadia Publishing,
an imprint of Tempus Publishing, Inc.
Charleston SC, Chicago, Portsmouth NH,
San Francisco

Printed in Great Britain.

Library of Congress Catalog Card Number: 2003108119

For all general information contact Arcadia Publishing at:
Telephone 843-853-2070
Fax 843-853-0044
E-Mail sales@arcadiapublishing.com
For customer service and orders:
Toll-Free 1-888-313-2665

Visit us on the internet at http://www.arcadiapublishing.com

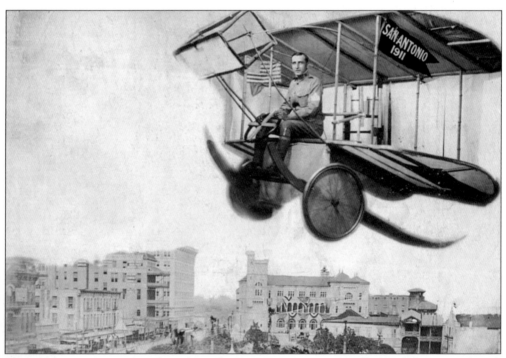

The whole country was awash with airplane expositions in 1911. Photographers armed with proper propsΔ and costuming could add anyone in the "air" over their favorite city. Such trick photography that put famous flyers in the air was common.

IMAGES
of America

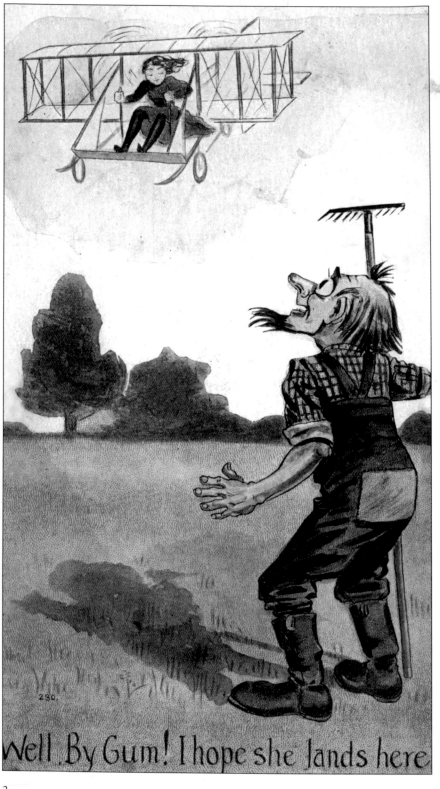

Well .By Gum! I hope she lands here

There must have been a certain male attraction to women who chose to fly in the early days of aviation. The women even had their own gender name, Aviatrix. While some cards poked fun at women who did manly things, this postcard treats the subject in a positive way, "I hope she lands here!" The card may reference the darling of the air, Katherine Stinson.

CONTENTS

ACKNOWLEDGMENTS

We would like to thank Dr. Kenneth Packer for asking us to do this book. Working with him and his employees was great fun. To several of Packer Engineering employees we give special thanks for their help: Steve Meyers, John Nowicki, Sara Thompson, Penny Rusch, Sandy Weiss, Pat Picardi, and Rosemarie Saramuzzo. Thanks also to Mark Miller and Chuck Clendenin of the Wright Redux project for taking time to share with us.

Several other people and companies have played a large part in making this book happen. As with all Chicago related projects, we owe a great deal to Len Duszlak. We would not have been able to put together this book without his great collection of all things related to Chicago and flight. Other collectors who have been very generous with their time, information, and photographs are Jack Roderick, Ted Koston, Carroll Gray, Joe DePaulo, and Nancy Wright. As always, the Aurora Public Library Reference Section was very helpful.

All of the companies currently doing business in Chicago that responded to our requests were very helpful and shared interesting photographs with us.

Our thanks goes to Scott Newton of Apex Media Solutions, Jo Krotz of T.I. International, Ltd., Andy Faville of Falex Corporation, Scott Newton of Arrow Gear, Kei Nanimatsu of Micro Lamps, Andy Kozlowski and Margaret Kozlowski-Van Horne of A.M. Precision Machining, Inc., Bob LaFrance of Scot Incorporated, Bobbi Khant of Scot Electrical Products, Tom Jacobs and Steve Chobanian of Recon/Optical, Inc., Bob Atac and Hart Gately of Flight Visions/CMS Electronics Aurora, Inc., Stanley Tesler of Fargo Manufacturing, Katy Lamb of Northrop Grumman, and Carol Waits and Frank W. Buck of Boeing.

We don't often dedicate a book to someone special, but the topic indicates that this book on flight should be dedicated to our aviators' newest addition, Zachary Ross. May he grow up to enjoy flying as much as his parents do.

INTRODUCTION

It only takes twelve seconds to change the world. At 10:30 a.m. on December 17, 1903, Orville and Wilbur Wright achieved the first successful powered manned flight of an airplane. They were in the air for only a few seconds, but modern aviation was born that day.

Right from the start, Chicago has played a key role in the 100 years of aviation since then. It was in Chicago that the flying bug first bit the Wrights in the 1890s. Years before the Wrights began their flying experiments, Chicago's Octave Chanute, President of the Western Society of Engineers, and other local enthusiasts were making gliders take to the air at the nearby Indiana Dunes. Chanute became a friend, mentor, and collaborator to the Wright brothers.

Aviation started out as a pastime, but due to wars, quickly turned into a serious business. Worldwide aviation became a major influence in the growth of nations and cultural diffusion during the last decades of this past century. To one who has been alive nearly 80 percent of that time, the changes in society, the phenomenal events and achievements of these years seem truly remarkable.

From the days of the first airplane tinkers, Chicago has been on the center stage of aviation with their daring young men and women in their flying machines, the city's numerous and early world-class air shows, and its airplane industry making planes and parts.

Chicago's early airfields such as Grant Park live on, but many in different forms. Chicago airports handle more than seven million passengers every day with 100,000 daily flights. Daily cargo exceeds 260 billion pounds.

To celebrate 100 years of flight, a group of Chicago aviation enthusiasts, from high school students all the way up to Ph.D.s joined together to build a Wright Flyer and reenact, here in Chicago, that seminal event that took place on the North Carolina sands.

I am proud to be a volunteer among so many that put hours into bringing this dream to reality. What magical things will the next 100 years bring? This is truly an exciting prospect. I can hardly wait!

Dr. Kenneth Packer

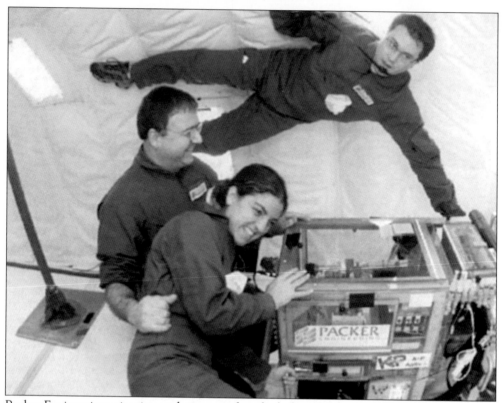

Packer Engineering scientists took time out for a little fun when they studied the solidification characteristics of materials in micro-gravity.

One

PLAYMATES

OF THE CLOUDS

It seems that man has always been fascinated with flying. From the earliest of times, birds have been envied and deified. The desire to soar into the sky like a bird is found in the mythology of cultures and civilizations in both hemispheres. The first to use a heavier-than-air device to fly was Archytas of Tarentum, father of the kite, in 400 B.C. Later, Leonardo De Vinci was an early scientist who experimented with bird-like gliders.

Otto Lilienthal, a German, is credited to be the father of all modern airplane experimentation. Lilienthal had observed the way the clothes on a line blew out in a curved plane and lifted above the line. He began a long series of glider flights in 1891 and is said to be the first man to soar like a bird in a sustained flight. He was killed in a 50-foot fall.

Other "birdmen" died perfecting their planes. Englishman Percy S. Pilcher came up with an idea for a propeller-driven monoplane but didn't survive his experimentation. The first person to actually fly in a powered plane was Frenchman Clement Ader who flew a steam-driven monoplane for 150 feet in 1890, according to claims by France. Englishman Sir Hiram Maxim, a former Texan, built a huge steam-driven craft that lifted off a guide track in 1894.

The Chicago connection with aviation started with balloon assents and the work of Octave Chanute, the father of biplane-designed gliders. By the 1900s, Chicago's sky was filled with gliders and powered airplanes piloted by daring men and women. Chicago became one of the "hotbeds" of aviation in the United States. The city went fly-crazy in 1911 during the international fly-in exposition! Here is but a glimpse of the early days in Chicago aviation history.

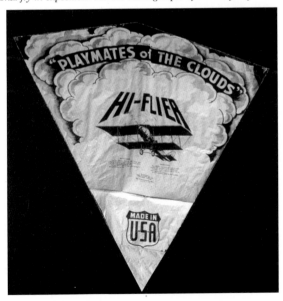

The Wright Brothers were successful bicycle manufacturers in 1896 but were bitten by the flying bug. The first things they built were kites, and then gliders that were flown as kites. This is a 1923 Hi-Flier kite made in Decatur, Illinois. Note the connection made between kites and airplanes.

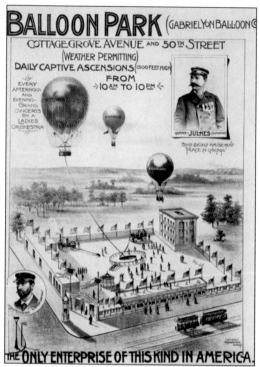

Among the many sports that developed and became popular in Chicago after the Civil War was ballooning. P.T. Barnum came to town in 1875 with a show whose central attraction was a balloon ascension. Unfortunately the balloonist and the accompanying reporter were killed when their balloon disappeared over Lake Michigan. The ad promotes a later balloon park at Cottage Grove and 50th Street.

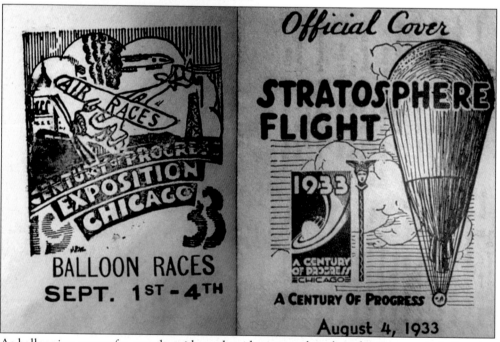

As ballooning grew safer, people paid to take rides just as they do today. Interest in ballooning did not fade, even after the motorized airplanes became popular. The airplane simply joined the fun of getting people in the air. These first day covers from the 1933 Century of Progress Exhibition in Chicago show how popular both forms of flight were at expositions and fairgrounds all across the country.

Octave Chanute was an early experimenter with flying machines. He was chairman of the organizing committee of the Third International Conference on Aerial Navigation, which was held at the World Columbian Exposition in 1893. Using his engineering training as a bridge builder, he and Augustus Herring worked together to perfect an exposed truss glider which could fly over 200 feet in 1896. This biplane and its descendants became some of the most successful early heavier-than-air flying machines.

Chanute's work helped countless aircraft builders, and he was always willing to share his ideas and research with others such as the Wright brothers who got in touch with Chanute by way of the Smithsonian Institution in 1899. Chanute never flew himself, feeling that he was too old. Shown here is a Chanute glider, c. 1896.

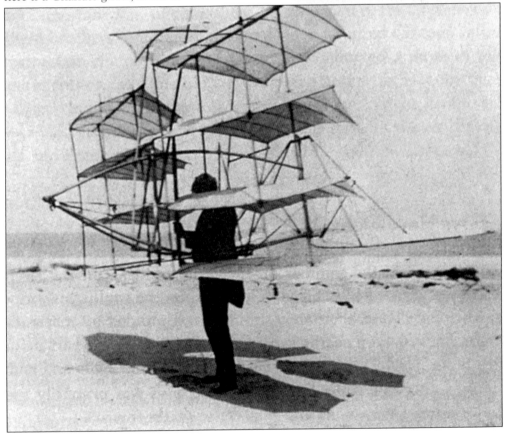

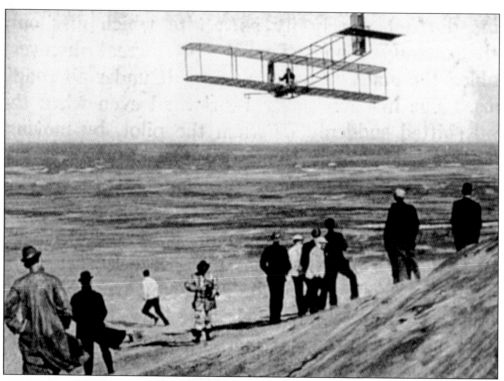

French engineer Alexandre Eiffel found, by calculation and experimentation, that a wing that was thick on the forward edge and tapered in a gradual curve to a thin edge behind possesses greater lifting qualities and less resistance. In the first Wright machines a horizon rudder was used in front to correct the tendency to pitch. This proved to be an unsuccessful solution. Here is a Wright glider over the Indiana Dunes.

Early flyers in Chicago organized the Aero Club of Illinois and a group called the Early Birds Club in December of 1928. At the first Early Bird meeting were, from left to right, Charles "Pop" Dickinson, president of the Aero Club of Illinois, and Jack and Marjorie Stinson. Membership in the Early Bird Club was restricted to those who had soloed in any aerial craft, lighter or heavier than air, prior to December 17, 1916.

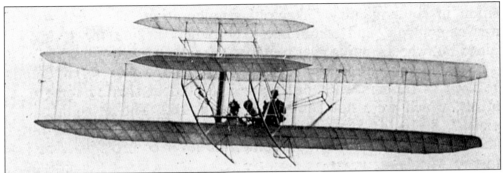

The U.S. military became involved with aviation in 1898 when it funded the building of an aeroplane by Samuel P. Langley. In 1903, Langley's full sized Aerodrome twice failed to fly from the Potomac River. Fearful of failing again, the U.S. Army and Congress waited several years before funding another plane. In 1908, they paid the Wrights $25,000 to build the military biplane Model A, shown here, which could carry two people at a top speed of 40mph.

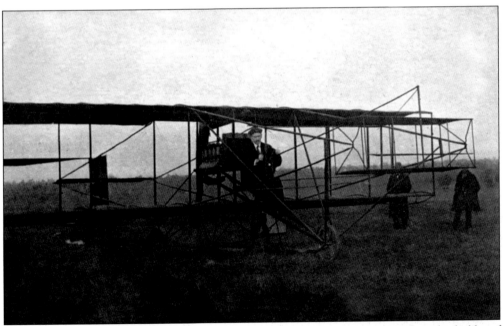

Glen Hammond Curtiss' first passion was for motorcycles. He was introduced to the hobby of aviation by Alexander Graham Bell. Curtis and Augustus M. Herring formed the first aircraft manufacturing plant in the United States. Later Curtiss and the Wrights would join together to build planes. Early on, Curtiss envisioned the idea of an aircraft carrier, which Lindbergh latter championed. In 1909, Curtiss won a speed contest at an annual meeting in Reims, France.

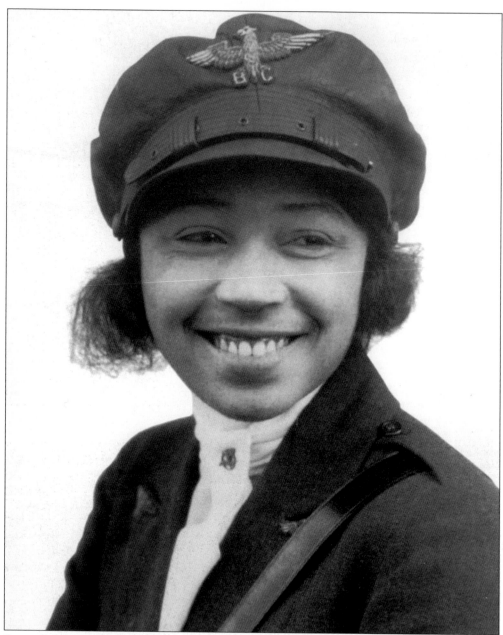

Bessie Coleman, of Atlanta, Texas was born in 1892 as one of 13 children. Her family was poor and she was needed in the fields, but she squeezed in time to read books and attend some formal schooling. Coleman moved to Chicago in 1915 and joined two of her brothers who were living there. She attended the Burnham School of Beauty Culture and became a manicurist.

Her brothers told her of their experiences while serving in France during World War I. There, blacks did not face racial prejudice, and women were learning to become flyers. Coleman tried to learn to fly in the U.S., but no pilots would teach a black woman. She traveled to France in 1920 and earned her International Aeronautics license in 1921, the first woman to receive this honor. She returned home and became famous as "Queen Bess-Daredevil Aviatrix." She refused to appear in air shows that did not allow blacks to attend.

Bessie never got to found a school for black aviators, which was her dream, for she died on April 30, 1926. Bessie fell from her plane cockpit practicing for a show in Orlando, Florida. Coleman is buried in Lincoln Cemetery in Chicago. She and Charles Alfred Anderson are knows as the Mother and Father of Black Aviation. After attending the Chicago School of Aviation, "Chief" Anderson taught Tuskegee Institute's famous 99th Pursuit Squadron.

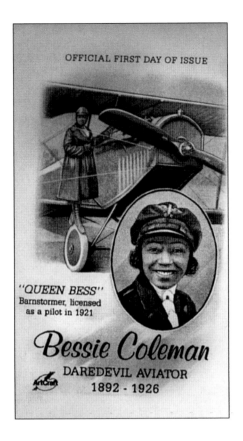

OFFICIAL FIRST DAY OF ISSUE

"QUEEN BESS"
Barnstormer, licensed
as a pilot in 1921

Bessie Coleman
DAREDEVIL AVIATOR
1892 - 1926

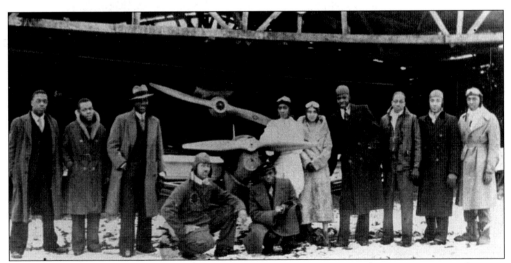

Other early Chicago black aviators included Janet Harmon Bragg who was a registered nurse. She got a pilot's license in 1932 at the Aeronautical University, Inc. in Chicago. Cornelius Coffee went to aviation mechanic school in 1931 and co-organized the Challenger Air Pilots Association in 1932 with John Robinson, shown at far right, to promote flying among blacks in the Chicago area. He also built an airport in Robbins, Illinois, and during World War II, trained black pilots and instructors. (Photo courtesy of the Ted Koston collection.)

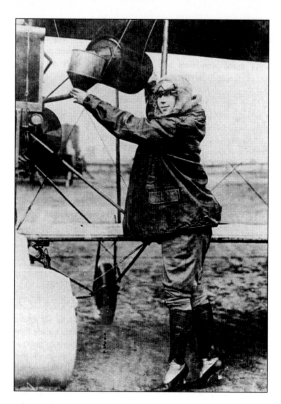

Carnivals and amusement parks found that stunt aviators helped bring in customers. Women who flew as daredevils created big box office receipts. Ruth Law was a popular flyer who set a long distance record of 6 hours and 32 minutes in a flight from Grant Park to New York. She is seen here filling her plane with lubricant for the long journey. In her day, she was as famous as Amelia Earhart.

Aviators as well as movie stars were popular endorsers of consumer products. This Coca-Cola ad appeared on the back of a pamphlet on aviation history, and in 1929 Amelia Earhart appeared in an ad for Lucky Strike cigarettes saying that she carried them with her on her plane, the *Friendship*, when she crossed the Atlantic.

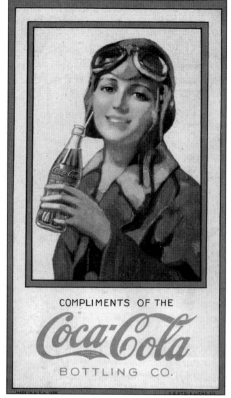

COMPLIMENTS OF THE

Coca-Cola

BOTTLING CO.

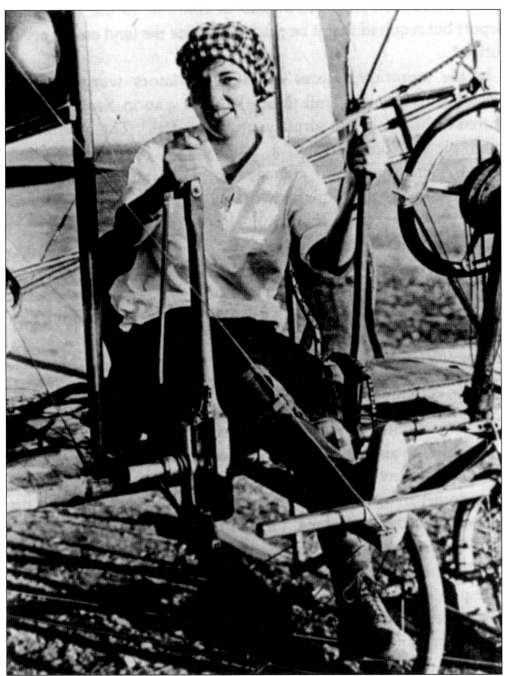

Katherine Stinson talked her sister, Marjorie, and her brothers, Edward and Jack, into learning to fly. Her brother Jack later founded Stinson Aviation Company. Marjorie, shown here, joined the rest of the family in establishing a flight school in San Antonio, Texas with the mother of the Stinson clan as the business manager. Marjorie and Katherine became the principal instructors at the school, and brother Eddie acted as the chief mechanic. Eddie died when he crashed his airplane into a flagpole on the Jackson Park golf course in Chicago, 1931. At his funeral a single plane flew overhead in tribute with Jimmy Doolittle in the cockpit.

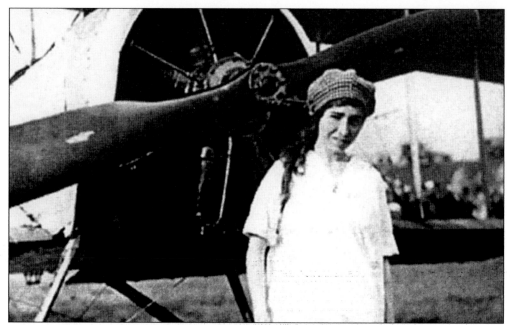

Katherine Stinson learned to fly from Max Lillie in 1912. The 100-pound Katherine traveled to Cicero to learn. Katherine learned to fly in only a few months, not only getting a pilot's certificate but also membership in the Aero Club of Illinois. She was billed as the Flying Schoolgirl. This picture is of Katherine at Ashburn Field.

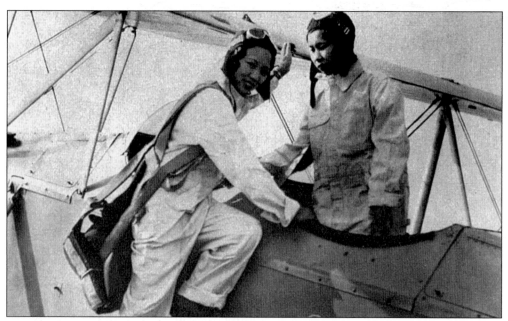

During World War II, the army gave women aviators the most dangerous roles to play. On the home front they flew new planes from the factories to embarkation points all across America. Jean and Anna Moy, Chinese school girls in Chicago, are posed in this photograph by a reporter for the *Daily News*, who quoted the girls as seeing, "no reason why they shouldn't pilot planes against the Japanese."

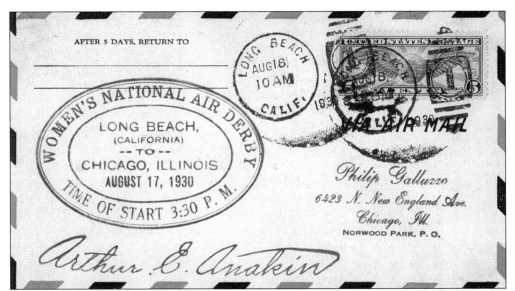

By 1930 there were enough women pilots that a Women's National Air Derby was held. The race started at 10 A.M. on August 17th in Long Beach, California with Chicago as the destination. Such races pushed the concept of sending mail by air at an additional cost over conventional mail. The post office issued a separate series of stamps for airmail.

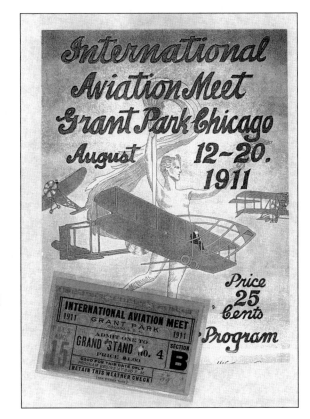

Chicago was not a stranger to big air shows. In 1910, Eugene Ely and J.D. "Bud" Mars entertained a huge crowd of 25,000 people at the Hawthorne Race Track. But in 1911, Chicago became the epicenter of Aviation for the world with its International Aviation Meet in Grant Park. Attendance on some days reached 200,000.

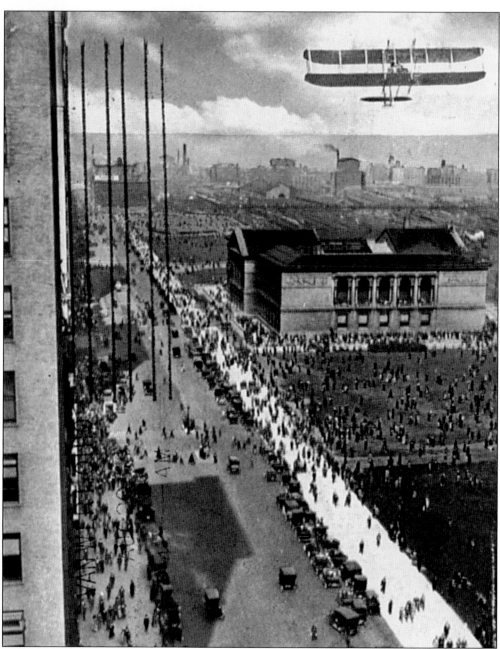

A large crowd gathered when Walter P. Brookins made the first confirmed flight over Chicago. He had actually flown over the city the previous year, practicing for the $10,000 prize offered by J.J. Kohlsaat, publisher of the *Chicago Record Herald* for a first flight from Chicago to Springfield. On September 27, 1910, Brookins took a newspaper reporter on several seven-minute spins over the Art Institute in practice for his next day departure for the Springfield Fair Grounds. Wilbur Wright, his former instructor, came to see Brookins begin his successful flight. It is hard for us today to think of the land behind the Art Institute as a site large enough for an air show. This postcard, however, shows the open fields of Grant Park around the building. Note Brookins and his aeroplane in the upper right corner.

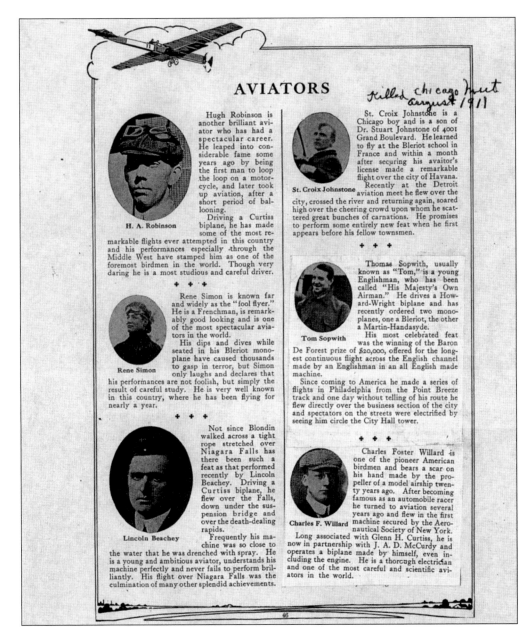

AVIATORS

Killed chicago meet August 1911

Hugh Robinson is another brilliant aviator who has had a spectacular career. He leaped into considerable fame some years ago by being the first man to loop the loop on a motorcycle, and later took up aviation, after a short period of ballooning.

Driving a Curtiss biplane, he has made some of the most remarkable flights ever attempted in this country and his performances especially through the Middle West have stamped him as one of the foremost birdmen in the world. Though very daring he is a most studious and careful driver.

H. A. Robinson

+ + +

Rene Simon is known far and widely as the "fool flyer." He is a Frenchman, is remarkably good looking and is one of the most spectacular aviators in the world.

His dips and dives while seated in his Bleriot monoplane have caused thousands to gasp in terror, but Simon only laughs and declares that his performances are not foolish, but simply the result of careful study. He is very well known in this country, where he has been flying for nearly a year.

Rene Simon

+ + +

Not since Blondin walked across a tight rope stretched over Niagara Falls has there been such a feat as that performed recently by Lincoln Beachey. Driving a Curtiss biplane, he flew over the Falls, down under the suspension bridge and over the death-dealing rapids. Frequently his machine was so close to the water that he was drenched with spray. He is a young and ambitious aviator, understands his machine perfectly and never fails to perform brilliantly. His flight over Niagara Falls was the culmination of many other splendid achievements.

Lincoln Beachey

St. Croix Johnstone is a Chicago boy and is a son of Dr. Stuart Johnstone of 4001 Grand Boulevard. He learned to fly at the Bleriot school in France and within a month after securing his avaitor's license made a remarkable flight over the city of Havana. Recently at the Detroit aviation meet he flew over the city, crossed the river and returning again, soared high over the cheering crowd upon whom he scattered great bunches of carnations. He promises to perform some entirely new feat when he first appears before his fellow townsmen.

St. Croix Johnstone

+ + +

Thomas Sopwith, usually known as "Tom," is a young Englishman, who has been called "His Majesty's Own Airman." He drives a Howard-Wright biplane and has recently ordered two monoplanes, one a Bleriot, the other a Martin-Handasyde. His most celebrated feat was the winning of the Baron De Forest prize of $20,000, offered for the longest continuous flight across the English channel made by an Englishman in an all English made machine.

Since coming to America he made a series of flights in Philadelphia from the Point Breeze track and one day without telling of his route he flew directly over the business section of the city and spectators on the streets were electrified by seeing him circle the City Hall tower.

Tom Sopwith

+ + +

Charles Foster Willard is one of the pioneer American birdmen and bears a scar on his hand made by the propeller of a model airship twenty years ago. After becoming famous as an automobile racer he turned to aviation several years ago and flew in the first machine secured by the Aeronautical Society of New York. Long associated with Glenn H. Curtiss, he is now in partnership with J. A. D. McCurdy and operates a biplane made by himself, even including the engine. He is a thorough electrician and one of the most careful and scientific aviators in the world.

Charles F. Willard

46

At the 1911 air show some 37 aviators competed for over $70,000 in prizes. The important people sponsoring the show read like a who's who in Chicago at the time with Colonel McCormick's name right at the top. This was not the only air show that year in the United States (some 600 exhibitions had taken place) but it was the granddaddy affair of them all. Flyer Louis Mitchell was to fly a Wright plane but he was replaced by a flyer named Bridley and the late entry, aviator number 37, was A.L. Welsh. Most of the planes were Wrights and Curtiss'. There were Bieroits in attendance as well as a Brooks-Bieriot, Curtiss-Bieriot, Howard-Wright, and Brooks-Briston-Farman. H.A. Robinson, the first man to loop-the-loop on a motorcycle was there flying his Curtiss Biplane, Frenchman Rene Simons, called the *Fool Flyer*, piloted a Moisant, and young "Tom" Sopwith from England was also there. He was the first Englishman to fly over the English Channel and creator of the famous World War I Sopwith *Camel*.

21

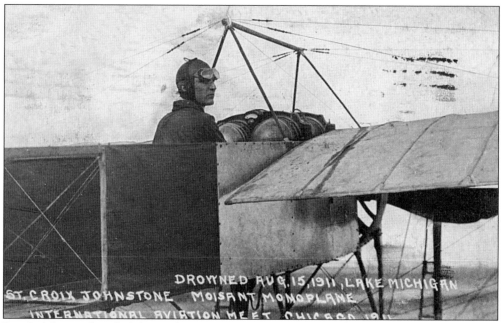

Death did not take a holiday at this meet. Among the deaths was that of St. Croix Johnstone who drowned in Lake Michigan. Postcards like this one were available only hours after a tragedy and sold well to a crowd that was out for thrills and spills that added to the excitement. Chicagoan Johnstone had promised to "perform some entirely new feat."

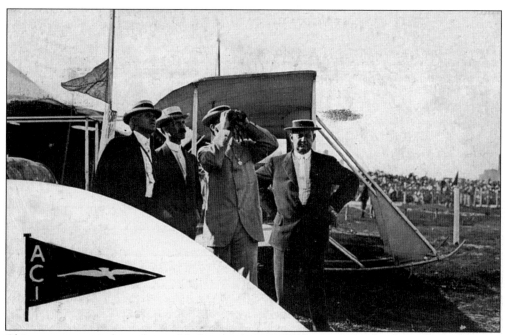

Chicago once again hosted a world-class air show in 1912, put on by the Aero Club of Illinois at Cicero Field. This postcard shows the pennant of the club with a bird and the letters ACI. Watching the airplanes in action are, from left to right, M.M. Wood, Orville Wright, and two unidentified men. This card notes that the writer took a ride in one of the planes.

Two

THRILLS AND SPILLS

As it turned out, World War I was not quite as it was billed. "The War to End All Wars" served only as a prelude to World War II. Trench warfare contributed to thousands of senseless deaths in France. The media, in an attempt to romanticize this barbaric war, latched on to the idea of gallant, present-day knights battling in the sky instead of on horseback. Actually, the aerial war was not a very important aspect of the battle, but was publicized to keep spirits up in combatant countries. The airplane's chief function was to observe the location of enemy troops, not for dog fights in the air. Balloons and blimps carrying observers could also do this job but not as efficiently or quickly.

After the war, American aerial heroes found a nation mesmerized by aerial stunts often times performed by war veterans. Women pilots, who had been denied the right to fight in the war, engaged in death defying stunts for cash and fame in peacetime. Hawthorne Race Track in Chicago was where the great Lillian Boyer could be seen in the air hanging from the wing of an airplane by one hand in the 1920s! Pilots began to forget crop dusting or delivering airmail for a living; there were more bucks to be made in providing the public with thrills and chills in the air. Thousands came to Chicago to ride balloons, see dirigibles, attend fly-ins, and see the planes and flyers in international air shows. The average life expectancy of a war pilot had been about two weeks, but the causality list seemed almost as high during the aero crazy 1920s and 1930s.

Then, in Chicago, a tragedy occurred in 1919 of such magnitude that the city became a no-fly zone years before "9/11."

Flying was the subject of popular books and cartoon strips in the early part of the 20th century, and especially so in times of war. Science fiction writers had us in the air battling our enemies such as the "Red Mongols" in a 1929 strip called *Buck Rogers in the 25th Century*. This is a 1932 *Air Adventure* strip featuring a bad guy with a gun and an assertive female pilot.

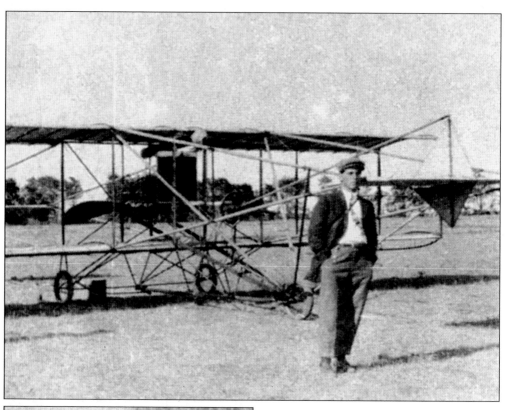

William Bushnell Stout took his first ride in a Farman biplane piloted by Otto Brodie, who flew exhibitions all across the country. Two weeks later, Stout recalls in his book *So Away I Went*, the tail came off the plane and Brodie was killed. That year, another flyer, "Tex" Jones, shown here, was making his way across Nebraska, appearing at the Pawnees County Fair with his "Air Circus."

Wing-walker stunt men and women came from all ethnic groups during the early days of barnstorming. This Polish dare devil is shown flying over what the caption called "I ziemia nad lotniskiem 'Harlem Airport' w Chicago." Thomas S. Gordon of Chicago took the photograph, *c.* 1920.

Colonel Lindbergh did his bit for crowds that gathered at county fairs to see Captain Wray Vaughn's Mile-Hi Flying Circus. One of Lindy's, standing center, favorite stunts was to drop a dummy body from his plane into a field beside the grandstand sending thousands of shocked people into the field to see Lindbergh's splattered remains. What they found was an old pair of Lindy coveralls stuffed with paper and rags.

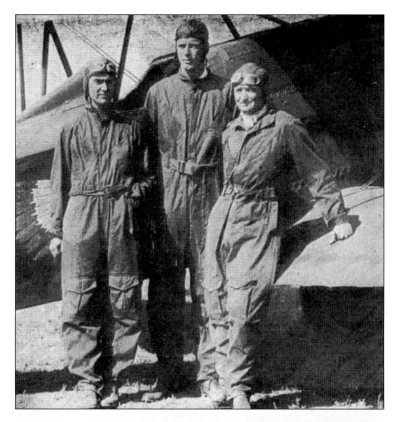

There is a fine line between a test pilot and a barnstorming pilot. Captain Wright (Ike) Vermilya, chief test pilot of Command-Aire, Inc., crawled out of the cockpit of his test plane on December 3, 1928 and rode the fuselage while the ship was flying at an altitude of 1,000 feet, to "test the stability of the plane" over Chicago.

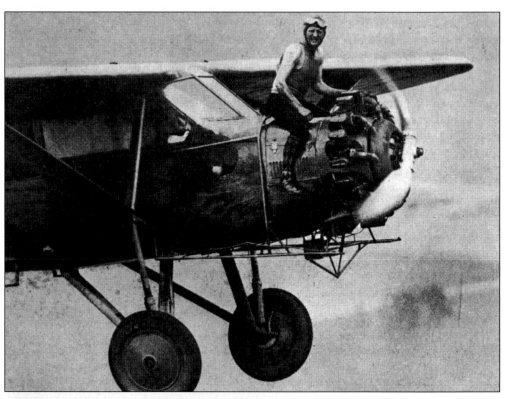

AVIATION MECHANICS

Gliders
Aircraft Engines
How to Build Airplanes
———•———
ALL ABOUT AVIATION

Edited by
HUGO GERNSBACK

John and Kenneth Hunter set a new international refueling endurance record in Chicago in July of 1930 over Sky Harbor. They stayed in the air from June 11 to July 4, almost 554 hours in their plane called *The City of Chicago*. Their brothers, Albert and Walter Hunter, were flying the refueling plane called *Big Ben*.

Their J-6 Wright Whirlwind functioned perfectly. Kenneth had to climb out on the catwalk or fuselage to tweak the engine and remove debris, which had collect on the tail surfaces! A total of 8,405 gallons of gas were used to maintain an average speed of about 70 mph for the 40,000 mile journey.

When the magazine *Aviation Mechanics* was launched in September 1930, publisher Hugo Gernsback chose to adorn his first cover with a dramatized drawing of Kenneth Hunter taking care of *The City of Chicago*.

After the Hunters' spectacular flight, endurance flyers Henrietta Sumner and Jean LaRene tried to set a new record in Chicago and failed. Here they are above the Oklahoma City airport trying again. The Hunter brothers are in the plane above, helping them refuel.

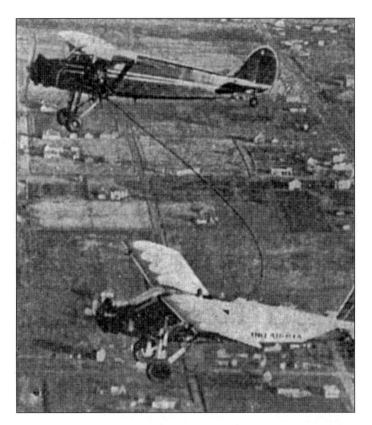

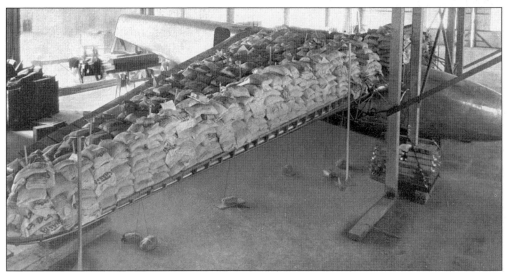

Barnstorming pilots did much to advance aircraft testing by hanging or walking on wings and riding the fuselage like a cowboy would ride a horse. More sophisticated approaches to research were made by the U.S. Department of Commerce to calculate static load tests. They used 29,000 pounds of silica sand to test the wings and 10,000 pounds of lead to test engine supports of a Lockheed 12 plane.

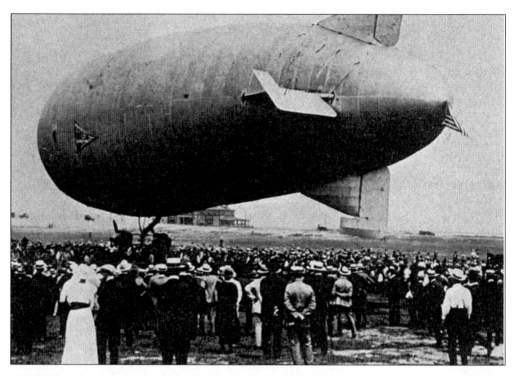

The $100,000 Goodyear *Wingfoot Air Express* was built in Akron, Ohio but final assembly took place at Chicago's White City Amusement Park. It was ready for its maiden voyage to Grant Park on July 21, 1919. Before the flight, mechanics corrected a fuel mixture problem, and the blimp took off from Grant Park.

At about 1,200 feet in the air after leaving Grant Park, disaster struck. The flaming ship plunged into the Illinois Trust and Savings Bank at LaSalle and Jackson. The blimp's heavy parts went through the skylight and the engine traveled through several floors before landing, as did mechanic Carl (Buck) Weaver's body. He was the first to leap from the burning ship, but his parachute burned up. The parachute of Earl Davenport, public relations director for White City, got caught in the falling passenger compartment. Henry Wacker, the other mechanic parachuted to safety but broke his back.

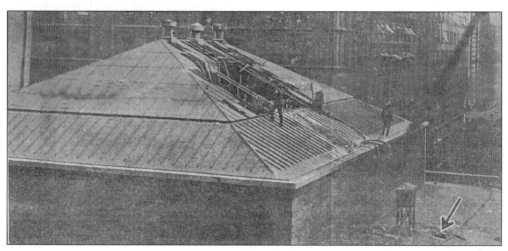

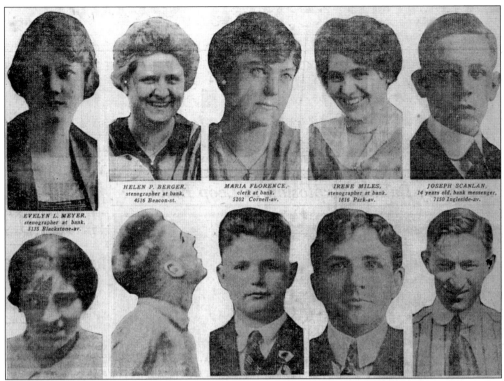

HELEN P. BERGER,
stenographer at bank,
4516 Beacon-st.

MARIA FLORENCE,
clerk at bank,
5202 Cornell-av.

IRENE MILES,
stenographer at bank,
1816 Park-av.

JOSEPH SCANLAN,
14 years old, bank messenger,
7150 Ingleside-av.

EVELYN L. MEYER,
stenographer at bank,
5135 Blackstone-av.

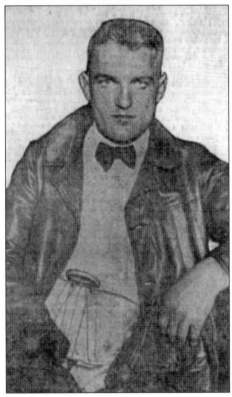

When the blimp hit the building's ceiling ironwork, its fuel tank exploded, deluging the bank employees below with blazing oil. Thirteen people were killed and 20 injured with 10 of those being bank employees, mostly stenographers and young bank messengers. The above photo is missing one of those killed, but shows Carl (Buck) Weaver (bottom row, second from left). Passenger William G. Norton, a reporter for *Chicago Herald and Examiner*, parachuted out but broke both legs. The great tragedy was that the captain, Jack Boettner (pictured at right), had intended to fly away from Grant Park south along the lake shore but the photographer talked him into turning east and flying over the city so he could take photographs. Boettner parachuted onto the roof of a nearby building and was unharmed.

Chicago Chief of Police Garrity, Assistant Prosecutor J.C. Lowrey, and Police Lieutenant John Naughton interviewed Boettner and he was held for an official inquiry. In an almost unbelievable short period of time, the Chicago City Council took action to prohibit flying over the city.

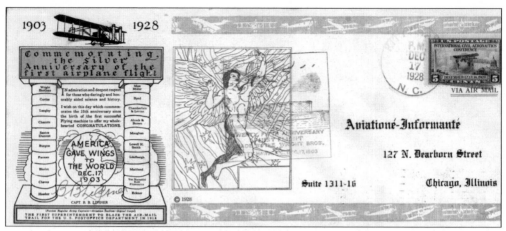

Rarely does one historical document have so many connections. This is a commemorative letter mailed to Chicago that celebrated the 25th anniversary of the Wright brothers' first flight. Orville Wright and the first superintendent of the U.S. Airmail service, B.B. Lipsner, carried the letter in a mail sack on December 19, 1928. They flew from Washington D.C. to Kill Devil Hill, North Carolina where Mr. Lipsner signed it and mailed it to Kitty Hawk.

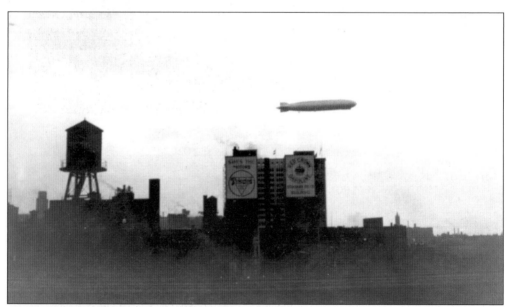

The Hearst Zeppelin made an around the world flight in 1929 and on August 29th was over the City of Chicago. Amateur photographer Charles Hoesttrich captured this view of the event and noted "Graf Zeppelin on his return round the world flight taken from the roof of the Southern Hotel, Chicago, Illinois Aug 29, 5:20 p.m."

The 1930 National Air Race was billed as "A Thrill for the Nation" and was sponsored by the Chicago Air Race Corporation. It was designed to accommodate 75,000 visitors. General admission was $1 and a season ticket could be had for $25. A year earlier, Col. Robert R. McCormick and other civic leaders had raised $250,000 for the show. The show was set up as a not for profit event. During the air show, the airport only allowed planes to land on the field at specific times between events. A huge Stop-and-Go sign was used on the field to control landings and take-offs. If the "Stop" sign was shown, planes had to circle to the west.

There were races that were billed as "Civilians' free-for-all," which were open to women too. Women had closed course racing, one for those who had closed cockpits and one for those with open cockpits, as well as a dead stick landing contest. Race groupings were determined by engine size ranging from 350 cubic inches up to 1,000 cubic inches.

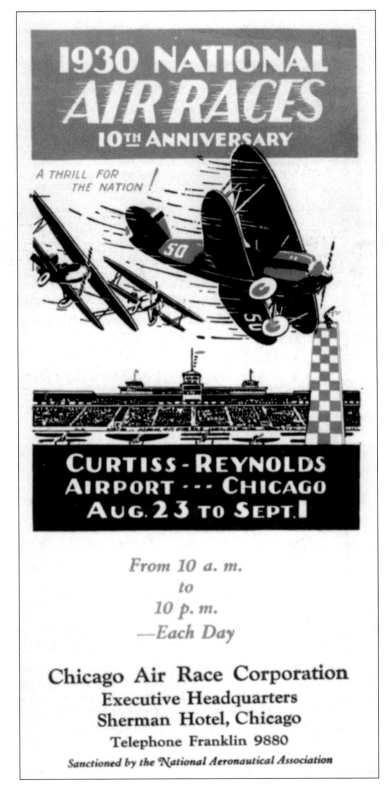

1930 NATIONAL AIR RACES

10TH ANNIVERSARY

A THRILL FOR THE NATION !

CURTISS - REYNOLDS AIRPORT --- CHICAGO AUG. 23 TO SEPT. 1

From 10 a. m.
to
10 p. m.
—Each Day

Chicago Air Race Corporation
Executive Headquarters
Sherman Hotel, Chicago
Telephone Franklin 9880
Sanctioned by the National Aeronautical Association

The 1930 National Air Race consisted of 10 days of non-stop entertainment. Each night ended with a fireworks display. At the race, customers were promised over 1,000 airplanes and 400 pilots. There were seven national air derbies, 44 speed races, acrobatic teams, and "Mystery planes speeding at more than 200 miles an hour."

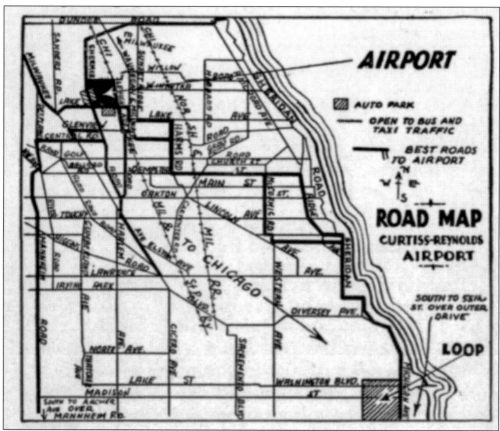

National Air Races were held only 45 minutes from the Loop. Large crowds were expected so extensive traffic control plans were made. The Milwaukee Railroad provided service to the show and 35,000 free parking spaces were available. A force of 400 traffic police was in constant contact by radio with airplanes overhead to help solve congestion.

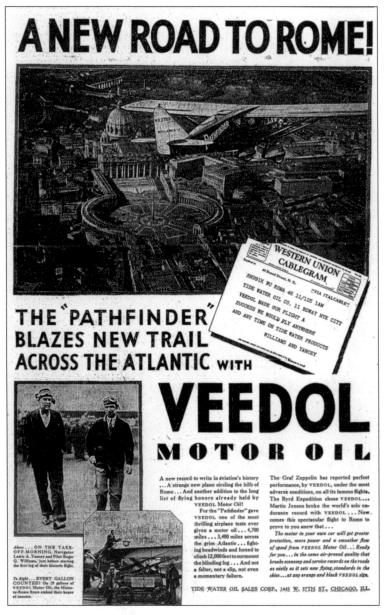

Tide Water Oil Sales Corp, which had offices at 1445 W. 47th Street in Chicago and 11 Broadway in New York in 1929, produced the popular VEEDOL Motor oil. They needed a gimmick to tout their major product. How about a flight across the Atlantic to Rome to prove the quality of their product? The Graf Zeppelins were already using their oil. The Byrd expedition and Martin Jensen broke the world's solo endurance record with VEEDOL. They did it by hiring pilot Roger Q. Williams and navigator Lewis A. Yancy to fly a Bellanca-J across the Atlantic. The ship was named the *Pathfinder* and was loaded with 19 gallons of VEEDOL motor oil for the 4,700-mile journey, of which 3,400 was over the Atlantic. At times they were forced to climb to 12,000 feet to escape fog. A cable sent from Rome to Tide Water oil became a classic example of great advertising, "we would fly anywhere and any time on Tide Water products. (signed) Williams and Yancy."

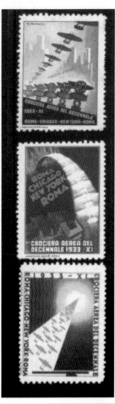

Countries found that they could issue commemorative stamps for collectors who would never use the stamps. This proved to be quite a moneymaker for the postal service. Here are the Italian stamps issued for a flight from Rome to Chicago in 1933 at the time of the World's Fair. Perhaps the visit to Chicago was payback for an earlier flight made in 1929 when we flew to Rome.

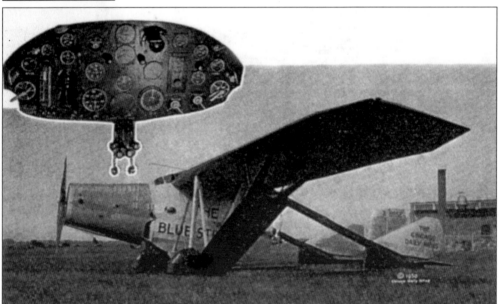

Newspapers in Chicago strove to scoop their rivals with exciting copy and prize-winning photographs such as those taken of the 1919 air disaster. In the 1930s, the *Chicago Daily News* was using one of the strangest planes in the air. It was a Bellanca with an instrument board (inset) equipped with the latest instruments for blind flying and navigation. Breaking stories were only minutes away for reporters and photographers with this futuristic airplane.

Zeppelins were here, there, and everywhere at the World's Fair in 1933. The U.S. Navy's blimp made by Goodyear paid the Fair a visit in June and so did others. The dirigibles worst enemy was stormy, electrical weather. Although the Navy defended their air machines as being safe, they sometimes dropped from the sky. In September, their *Shenandoah* came apart over Ava, Ohio in a storm, and 14 of the 45-man crew died in the crash.

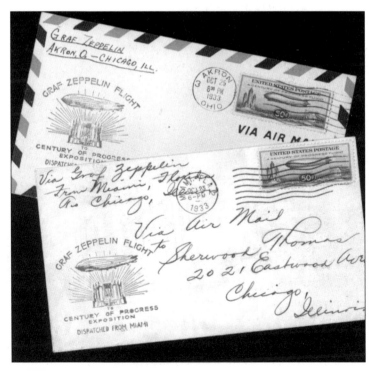

A Graf Zeppelin set out from Miami on October 23, and another left Akron, Ohio on October 25, bound for Chicago's 1933 World's Fair. Flying on a Zeppelin, according to those who had the money to fly, was an unbelievable experience. With motors far in the rear, away from the passengers, one seemed to float with the clouds. Zeppelin airmail covers from the Fair with 50 cent airmail Zeppelin stamps such as these shown above, fetch upwards of $150 each.

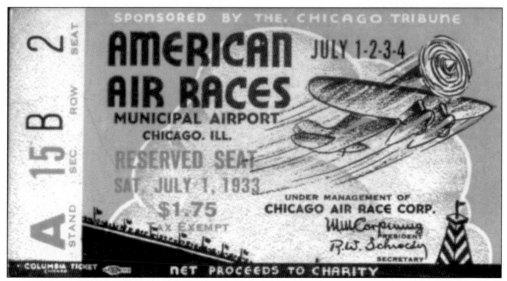

Long time aviation sponsor the *Chicago Tribune* sponsored the 1933 American Air Races held at Municipal Airport on July 1 through 3 during the World's Fair. All proceeds of the show went to charity. Here is a ticket for the Saturday show, priced at $1.75. On the back of the ticket were directions to the airfield, which was located at 63rd and Cicero.

By 1938 air shows in Chicago were carnivals. The International Air Show, held from January 29 through February 6 at the International Amphitheatre, was crackling with action, not only in the air, but also on the ground. Manufacturers showed their latest joysticks, the latest Piper Cub was on display, and American Airlines touted their new Skysleepers that flew from Chicago. There were singing acts and a ballet based on modern aviation.

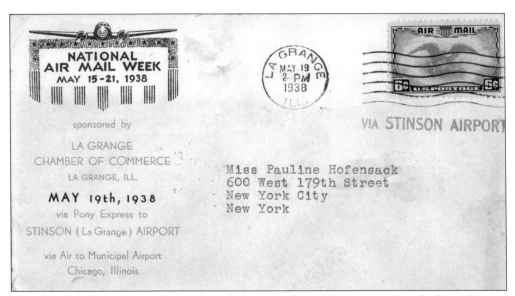

This interesting air mail letter really made the rounds in 1938. It is postmarked "La Grange, May 19, 2 pm." And was canceled "VIA STINSON AIRPORT' during National Air Mail Week, May 19-21. It was taken "via Pony Express [using race horses] to Stinson [La Grange] Airport via air to Municipal Airport in Chicago, Illinois."

Fuel for automobiles and airplanes was restricted during World War II to provide energy for the U.S. Army and Navy forces fighting overseas. Air shows and recreational use of airplanes were put on hold to support the war effort. "Everything for the Boys" was the motto, and even civilian aircraft such as the *Piper Cub* made its way onto the battlefield.

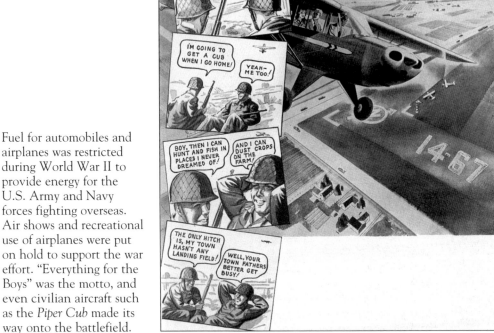

THE 30TH AIR & WATER SHOW

WIN THIS BEAUTIFUL ORIGINAL PAINTING! SEE PAGE 14

Chicago's love affair with aviation continued into the rest of the 20th century as numerous air shows came to town to thrill thousands on the lakefront and at nearby air fields. In 1988, the city celebrated the 30th Air Show sponsored by the Chicago Park District. The year before, there had been one and a half million spectators on hand for a "thrills and spills" experience. At the 1988 show, Illinois' Gene and Cheryl Rae Littlefield provided an old fashioned barnstorming act to keep the crowd on the edge of their sets. While Gene flew the bi-plane, his wife unfastened her seat belt-like harness that anchored her to the plane and disappeared into thin air, later reappearing on the lower wing. "Watch closely as they fly straight up, sideways, upside down, through loops and figure eights with Cheryl standing on the wings!"

Three
LINDBERGH
AND AIRMAIL

Under a string of Republican presidents in the late 19th and early 20th centuries, the United States often intervened in affairs to benefit American businesses. The country was a virtual hot house for the breeding and improvement of commerce. Our involvement in World War I gave a temporary boost to aviation, but with isolationism and disarmament all the rage after the war, something else had to keep money flowing into aviation companies. Airline companies began to merge and the government turned airmail routes over to private air services that bid on each route. Now, commercial airlines could count on revenue from passengers, airmail service, and cargo to keep their planes in the air and help fund improvements in aviation. Faster planes were always a goal because time was money. Airlines and rail lines devised clever ways to pick up and deliver mail sacks without stopping. Who first flew the mail? Many early airmail pilots served as World War I pilots who later combined barnstorming with stints of delivering the mail. Charles Lindbergh was part of a team that flew mail from St. Louis to Chicago by way of Springfield on what was the second air mail route established by the government. Chicago's post office, the "hub and spokes" of a tremendous amount of the country's airmail, became one of the world's largest processors of mail.

Fairchild Engineering ran an advertisement showing this picture in a trade magazine in 1941 noting that airmail no longer had to rely on planes that "fooled around with passengers." Now the world had a flying mail car, which could carry mail by the ton. Inside the plane there was an ingenious sorting section where clerks could sort the mail while in the air.

In 1911, pilot Earl Ovington was at an air meet at Garden City, New York where he took off every day for a week, carrying pouches of mail and flying the short distance to Mineola as a "stunt." On September 23, Postmaster General Frank H. Hitchcock was attending a meet sponsored by the Nassau Aviation Corporation and handed a pouch of mail for Ovington to deliver in his Bleriot.

The plane below, shown at Elizabeth, New Jersey on August 8, 1919, is one of the first group of specially built airplanes approved by the director of the government's new airmail service, Captain Lipsner. The planes had Hispano-Suiza eight cylinder 170 hp engines and could carry a mail load of 180 pounds going a top speed of 94 mph. Some of these were used on the Chicago to New York run.

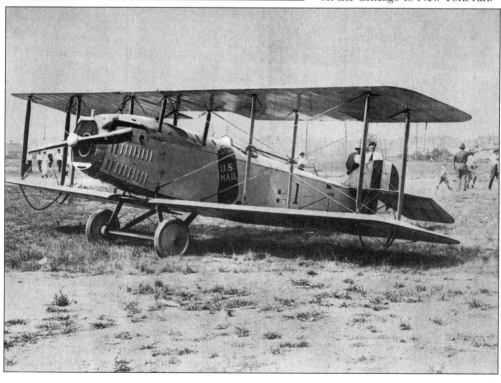

On April 15, 1926, the government granted contract air mail route 2 (CAM-2) to Robertson Air Company. Shown at right are some of the pilots who flew for Robertson, which would later merge with Universal, Colonial, Aviation Corporation, and Southern Airlines in 1934 to form American Airline, Inc. Pictured, from left to right, are: (top row) Walter Braznell, Ray Fortner, and Julius Johannpeter; (second row) Eyer L. Sloniger and Bert Ison; (bottom row) Harlan A. "Bud" Gurney, R.D. Newton, Kirby L. Whitsett, and Charles Lindbergh.

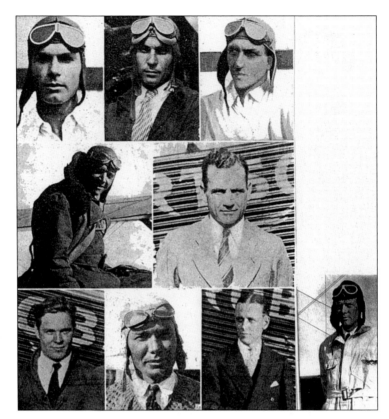

In 1923, William B. "Jackknife" Stout set out to build an all-metal plane. Henry and Edsel Ford became interested in this inventor's fresh approach to airline design. They each invested $1,000 in his work and later bought out Stout's factory. They switched to three Wright Whirlwind radial engines and the famous Ford TriMotor was born. This amazing picture of Stout's plane shows Charles Lindbergh at the controls and the world's most popular humorist, who was also an airplane enthusiast, Will Rogers. (Photo courtesy Ted Koston collection.)

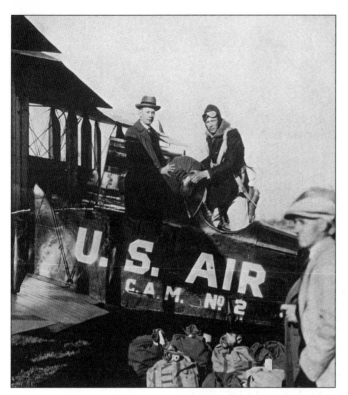

Before Lindbergh thrilled the world with his transatlantic trip to Paris, he made history by delivering the first airmail from Springfield to Chicago for Robertson Air Service. He is shown here taking a sack of mail from the Springfield postmaster on April 15, 1926. He used a refurbished World War I DeHavilland (nicknamed "Jennies") DH4, which was formerly used as a bomber.

As more and more planes made their way into the sky, it became important to know exactly where you were and where other planes in your area were located. General Electric was active in making air travel at night safer with their powerful lights. In 1923, they also created a radio for planes using Exide batteries. New airplanes in 1927 expanded their airmail compartments to carry 500 pounds of mail in the redesigned front cockpit.

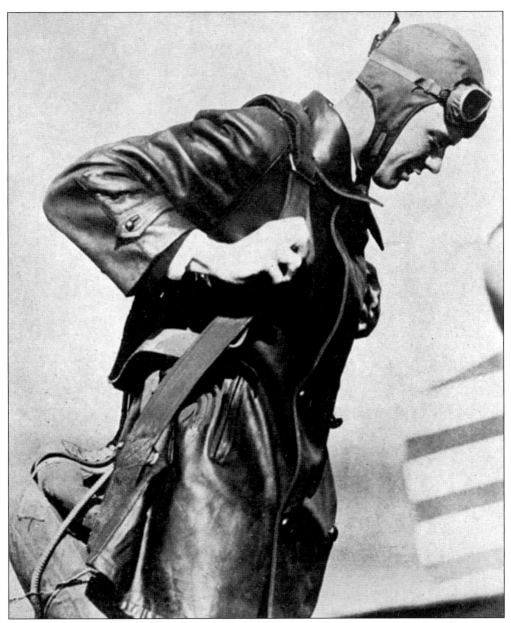

Flying the mail could be as treacherous as doing stunt work over county fairs. Parachutes were designed to save lives. Irvine Air Chute Co. of Buffalo, New York designed one of the most reliable parachutes in the 1920s and 1930s. Irvine created a group called the Caterpillar Club. Entrance to the club was gained when an Irvine chute had saved your life. It picked the name because, "The Caterpillar, letting itself down gently to earth on its silken shrouds, has been taken as symbolic for the action of the silken parachute."

Lindbergh, shown here, was saved on four occasions by his Irvine parachutes. The first time was at Kelly field in Texas on Mary 6, 1925. From 1918 through 1927, 34 airmail pilots died flying for the U.S. Air Mail Service. Nine died when their chutes did not open and others lost their lives due to fog trees, cables, and fences. William F. Blanchfield died in 1942 when his plane crashed over a cemetery during a funeral of another airmail employee.

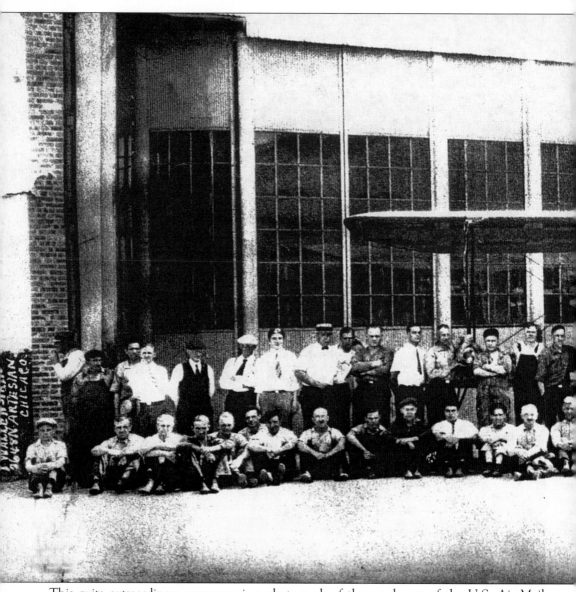

This quite extraordinary panorama is a photograph of the employees of the U.S. Air Mail Service in front of their hanger in Maywood, Illinois. They are grouped around a Jennie (DeHavilland DH-4). Note in the background the way hangers were designed in the late 1920s with a sliding vertical wall and lots of windows, like a typical factory, to let in as much light as

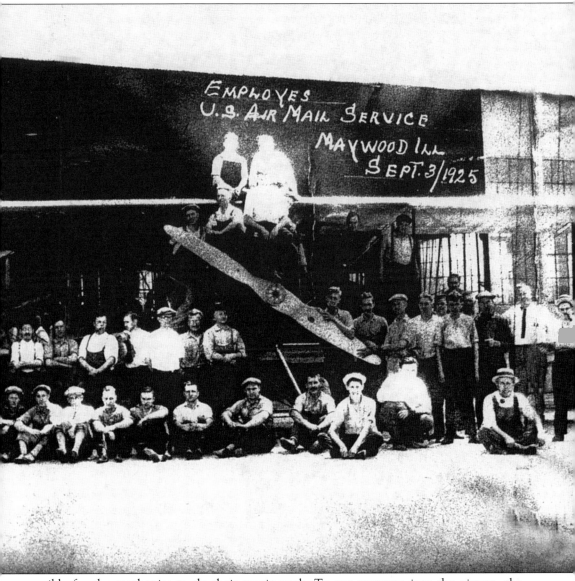

possible for the mechanics to do their repair work. To get everyone into the picture, the photographer creatively put workers on the top and lower wing as well as on the propeller and engine. The photo was taken by I. Wallenstein and is from the Pete and Milly Pearson collection.

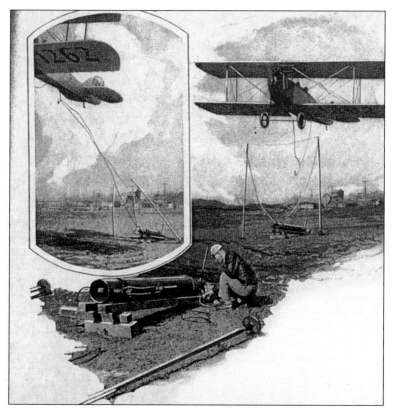

Various schemes have been used over the years to save time in picking up and dropping off mail from planes in the air and from speeding trains. A Kansas City aviator came up with a device in 1928 that would pick up gasoline, airmail, and express packages weighing up to 100 pounds. It was called a "synchronizing cannon." The device also used a shock-absorbing rope to lift off the mail at 500 feet per second.

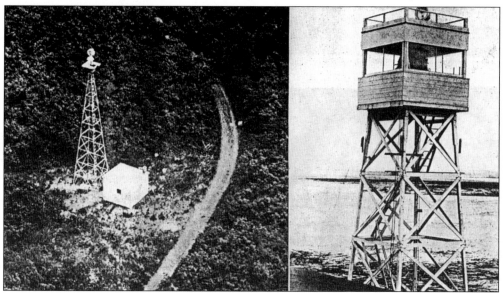

Flying the mail at night was difficult in the early 1920s, but by 1925 air routes had beacons to guide the planes along their way. The New York-Chicago Overnight Air Mail had twenty beacons, each powered by five million candle power and developed by General Electric Co., installed on wood and metal towers. For the 200 mile run between Chicago and Cheyenne, Wyoming they used Sperry Gyroscope beacons with 500 million candle power.

Four

FIELDS OF DREAMS

In the early 1900s, there were nearly three dozen small, scattered airfields that had sprung up wherever the plane owners could find land that could be used to take off, land, and store private planes. The first government airport opened in 1916 at Ashburn Field, located at Crawford Avenue and 83rd Street. It was followed by the opening of Chicago Municipal, which was dedicated at 63rd and Cicero in 1926. Most of the early, private fields have disappeared as the sites became much more valuable for real estate developments. But when you drive out into the countryside, grassy landing strips can still be found here and there. In 2003, another field of dreams disappeared forever—Meigs Field.

Chicago has held the title of "world's busiest airport" at three different airports. Cicero was one of the first fields to have any improvements and as such was the first to attract a large number of planes, thereby capturing the title. Municipal/Midway was the next, and that airport held the title for nearly 40 years. O'Hare later took the title from Midway.

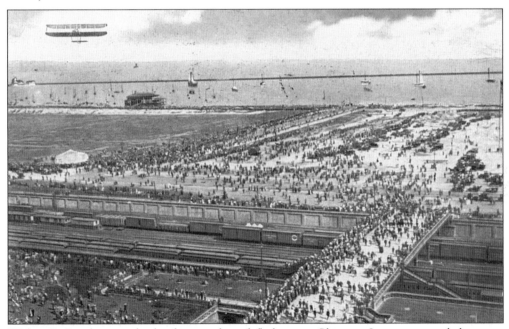

Walter P. Brookins made the first confirmed flight over Chicago. It was reported that over 200,000 people were on hand to see it. This trick postcard was made by placing a photo of Brookins over another picture of the crowd. Grant Park was the site for early air shows. It was convenient for people to visit and see all those crazy stunt flyers strut their stuff. The building in this picture is the Chicago Yacht Club.

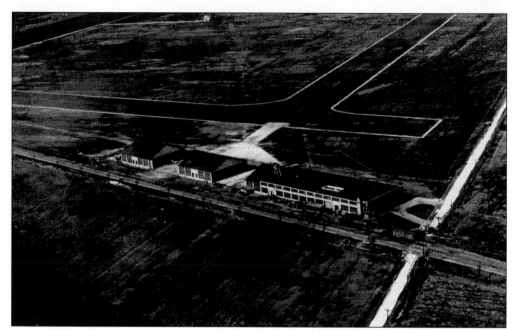

First Avenue separated Maywood Field and Checkerboard Field, which had been used for airmail service from 1920 until 1923 when a major fire put it out of business. Airmail operations flew from Maywood from 1923 until 1927 when they were shifted to Municipal Airport. This was the Maywood field in 1925. (Photo courtesy Ted Koston collection.)

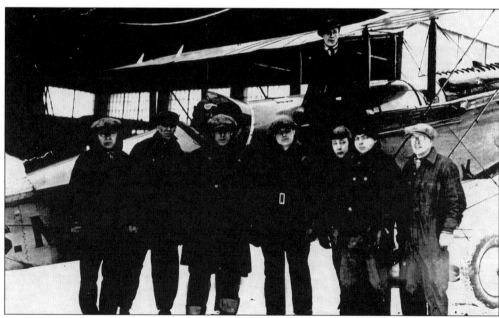

This 1923 photograph at Maywood shows airmail pilot George Myers in the cockpit and mechanics (from left to right) John Rudin, Carl Kjus, John Casey, Harry Rockwell, Pete Pearson, Tom Scully, and Clyde Hill. Joe Baltrusis is on the wing. In those days, flying the mail could be as dangerous as stunt flying. Watch for a later photo of John Casey at Municipal Airport. (Photo courtesy Ted Koston collection.)

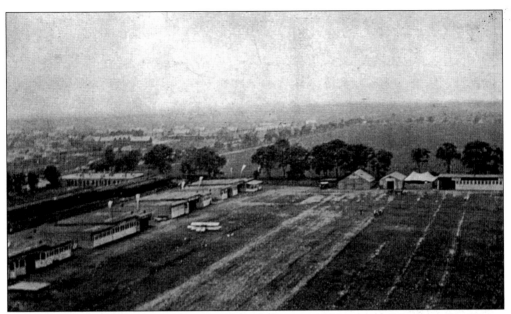

Harold F. McCormick offered the Aero Club of Illinois a 180-acre parcel he owned in Cicero to use as an airfield. The site was the area between 16th and 22nd Streets and 48th and 52nd Avenues with low buildings on three sides and a rapid transit line on the fourth. For several years, it was the only airport in the Chicago area.

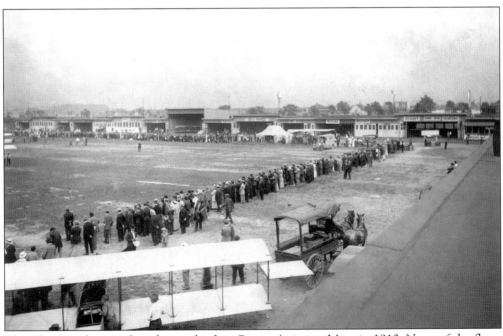

This photograph was taken during the first Cicero Aviation Meet in 1912. None of the flyers are identified, but flyers came from all over to participate in air meets in the early days. The plane in the left bottom corner is a Benoist Type XII tractor biplane. Cicero field was just a large flat grassy field as were most of the early fields. (Photo courtesy Carroll F. Gray Aeronautical Collection.)

These spectators are watching another of the spectacular air meets at Cicero Field. This field was one of the busiest and best equipped in the nation, and the Aero Club of Illinois sponsored some of their best air shows here. (Photo courtesy Carroll F. Gray Aeronautical Collection.)

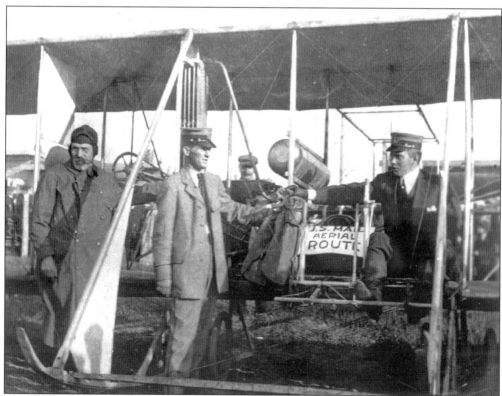

Aviator Max Lillie, left, is shown here at Cicero Field. Before official airmail was scheduled at Grant Park, pilots often provided airmail service on their own. When McCormick began selling off Cicero Field to developers, Charles Dickinson bought a site for Ashburn Field and paid for its development. He worked to get airmail service there, but the government chose Checkerboard Field instead. (Photo courtesy Carroll F. Gray Aeronautical Collection.)

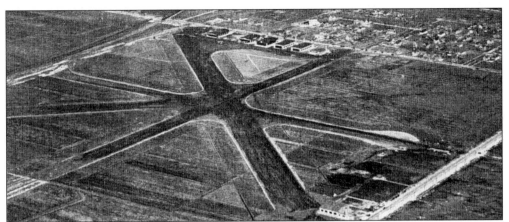

This 1928 photograph shows Municipal Airport with its cinder runways. Hale Elementary School is in the lower right corner. Along the top you can see, from left to right, a Ford three-motor plane that was owned by the Standard Oil Company as well as hangers of the Sievert Airplane Company, Boeing Air Transport, National Air Transport, Illinois National Guard, and Aviation Service and Transport.

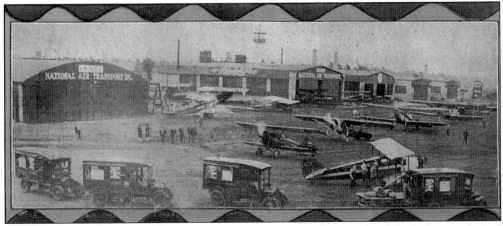

Here you can see all the activity of loading and unloading mail. Only 800 arrivals and departures were logged at Municipal in 1927, and most of the airport's activities centered on mail cargo, not passengers. National Air Transport, whose hangers are shown on the left side, and three other airlines would later merge to become one airline, United. That event is depicted on their planes by four stars painted on their shield.

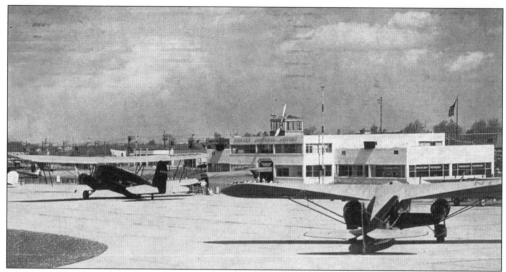

In 1931, a new terminal, designed by Paul Gerhartd Jr., was built for Chicago Municipal Airport. The concrete building was 162 feet long and 72 feet wide. You can also see that Municipal had concrete runways by this time. Passengers boarded outside until the late 1960s when covered passageways began to appear.

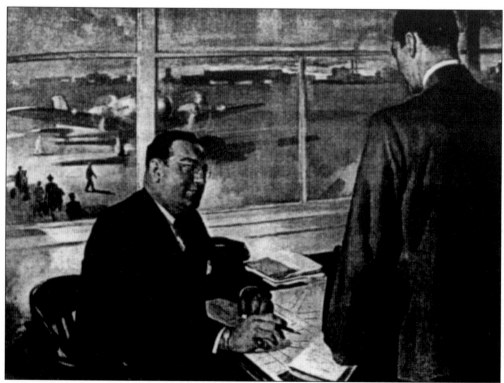

This painting of airport manager Col. John Casey (remember him?) was used to advertise two-way radios in *Aero Digest* during the 1940s. Casey's office was on the second floor and overlooked the field. He managed the airport for a number of years, first as a small field and later as the busiest airport in the world.

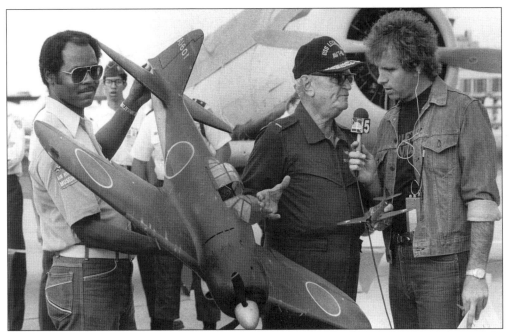

Municipal was renamed Midway after World War II, and it served as Chicago's main airport for over three decades. Shown here is Ensign George Gay (center), the sole survivor of the Battle of Midway, being interviewed by Channel 5's Jerry Taft in 1982. In 1932, Midway became the world's busiest airport and stayed the busiest until the end of 1960. The railroad tracks that bisected the airport were removed in 1941, and that year there were 85,000 take offs and landings.

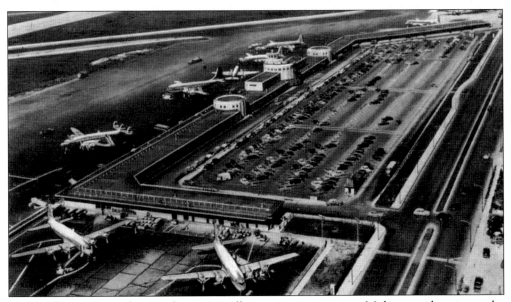

From 1955 to 1958, with more than nine million passengers per year, Midway was bursting at the seams. In 1959, the airlines began transferring some of their operations to the newly opened O'Hare, and by 1962, Midway was abandoned by the large airlines. Midway Airlines began using the airport in 1979 and today it is once again a viable airport with a new user-friendly terminal.

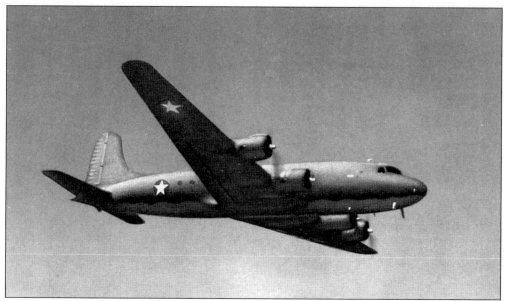

Douglas Aircraft Company, based in California, feared the possibility of a Japanese air strike if they built the C-54 Skymaster cargo planes there. They chose a small field called Orchard Place in a rural area northwest of Chicagoland for building these planes. The first C-54 was finished at that facility in July of 1943.

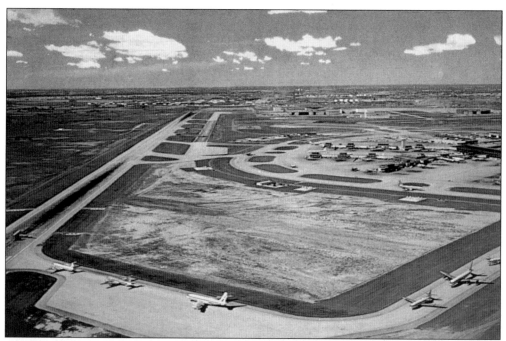

In 1946, the government deeded the Orchard Place site to the city of Chicago. An airport was opened that year; one without a name, without a control tower, without airlines, and without terminals. The first commercial plane (carrying cargo) flew in that October. This officially unnamed airport was called Chicago Orchard Field, hence the ORD that is the abbreviation for O'Hare Airport.

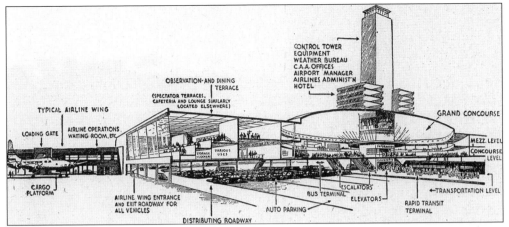

CONTROL TOWER
EQUIPMENT
WEATHER BUREAU
C.A.A. OFFICES
AIRPORT MANAGER
AIRLINES ADMINIST'N
HOTEL

OBSERVATION- AND DINING
TERRACE
(SPECTATOR TERRACES,
CAFETERIA AND LOUNGE SIMILARLY
LOCATED ELSEWHERE)

TYPICAL AIRLINE WING

GRAND CONCOURSE

LOADING GATE

AIRLINE OPERATIONS
WAITING ROOM, ETC

MEZZ. LEVEL

STORAGE
LOCKERS

VARIOUS
USES

CONCOURSE
LEVEL

CARGO
PLATFORM

ESCALATORS

BUS TERMINAL

←TRANSPORTATION LEVEL

AIRLINE WING ENTRANCE
AND EXIT ROADWAY FOR
ALL VEHICLES

ELEVATORS

RAPID TRANSIT
TERMINAL

AUTO PARKING

DISTRIBUTING ROADWAY

This drawing shows the O'Hare terminal as proposed in 1953. The passenger terminal was finished in 1955 and regular domestic passenger service began. The international terminal was completed in 1958 as part of the massive construction that was adding facilities to the airport through 1963.

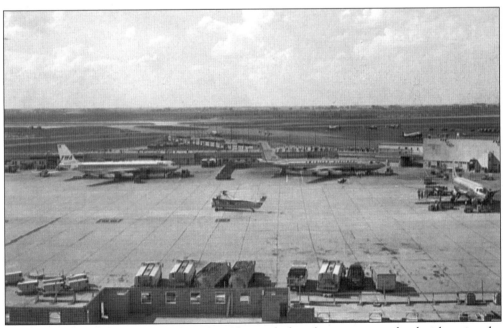

Edward "Butch" O'Hare, who had lived in Chicago before the war, was credited with saving the carrier Lexington. The Chicago City Council proposed to name the unnamed airport for him as O'Hare Field, Chicago International Airport. The 1958 council changed the name slightly to O'Hare International Airport.

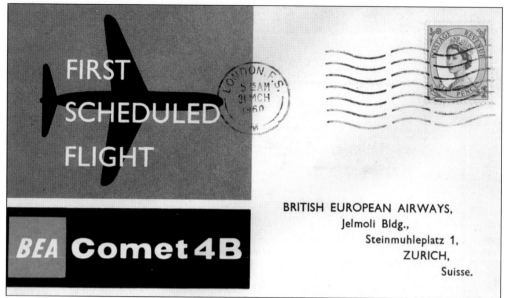

FIRST SCHEDULED FLIGHT

BEA Comet 4B

BRITISH EUROPEAN AIRWAYS,
Jelmoli Bldg.,
Steinmuhleplatz 1,
ZURICH,
Suisse.

A Comet 4 flew across the Atlantic on October 4, 1958 and was the first jet airliner to do so. This airmail, first day cover honored the first scheduled flight of the Comet 4B from London to Zurich and back. The Comet series of aircraft was manufactured by England's De Havilland Aircraft Co. beginning in 1952 but only 112 Comets of all types were ever produced.

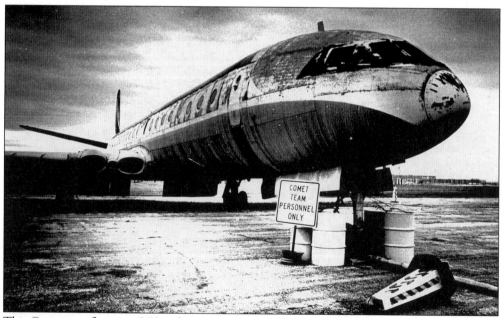

This Comet was flown to O'Hare but never flew again. After sitting for over 10 years, members of the Rotary Club of Chicago O'Hare realized the significance of the aircraft and in 1987 asked to be allowed to clean it up and find a permanent home for it. Two teams of volunteers spent countless hours cleaning and disassembling the aircraft to make it ready to ship by rail. One day, all of the pieces were accidentally put in garbage dumpsters.

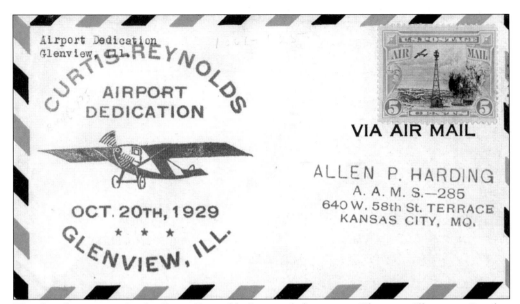

This first day cover is for the Curtis-Reynolds Airport dedication in Glenview, Illinois on October 20, 1929. The field was named for the Curtis Flying Service, and landowner Fred Reynolds. When the Naval Reserve Air Base needed more room than they had at Great Lakes in 1937, this field was chosen to operate as a Reserve Training Base, which it did until 1942. During World War II, the base was expanded to use for carrier quals, or qualifications, for carrier landings.

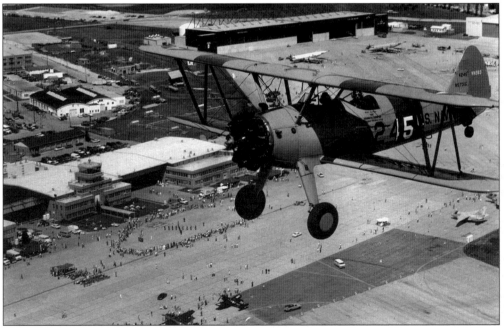

Tom Forys is shown here flying his Stearman N2S past Hanger One at Glenview in 1989. A large majority of aircraft on board carriers were planes such as this. Students from Glenview practiced landing on the Wolverine and Sable aircraft carriers in Lake Michigan during the war. In January of 1943, Glenview was renamed Chicago Naval Air Station. The base closed in 1995. (Photo courtesy of Ted Koston.)

Pal-Waukee Flying Service operated out of Gauthier's Flying Field, which opened in 1925 with a 40-acre grassy field with dirt runways. This photo shows the field in 1946 when there were gravel runways. Also, the name of the field was changed to Palwaukee about this time. (Photo courtesy of Ted Koston.)

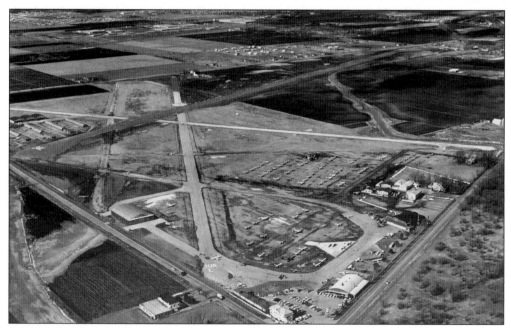

In 1986, the City of Prospect Heights and the Village of Wheeling purchased Palwaukee, which today serves as one of the nation's busiest reliever airports with as many as 180,000 takeoffs and landings being logged annually. Remember the projection of O'Hare's passengers in 1953? This photograph was taken when the North-South jet runway was under construction. (Photo courtesy of Ted Koston.)

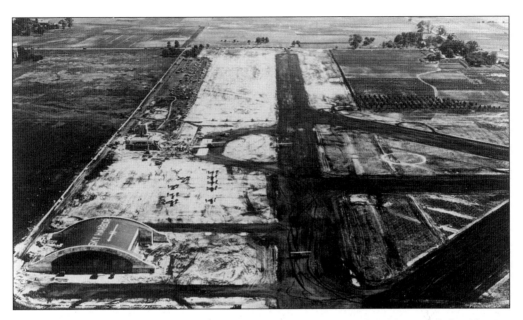

Sky Harbor Airport, in Northbrook, Illinois, was one of many small fields around the Chicago area. This 1930 photograph, above, taken just one year after the field opened, shows the field in the middle of near-empty land. Many of the pilots who housed their planes here worked downtown and would commute by air. They would "park" at either Meigs Field after it opened or at a ramp in Lake Michigan at Grant Park. The later 1946 view, shown below, shows some of the airplanes that were tethered at Sky Harbor. Look in the background to see military planes that had been purchased by individuals after World War II. This field was closed in 1972. (Photos courtesy of Ted Koston.)

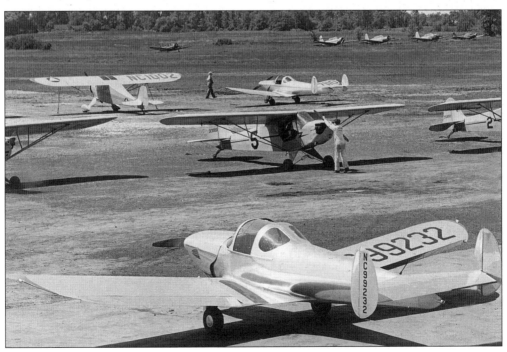

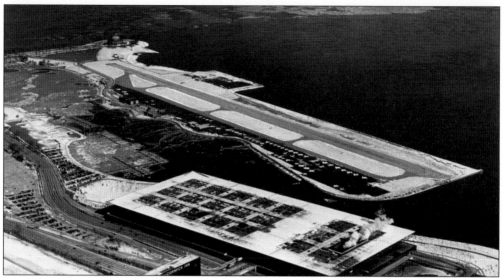

In 1922, Mayor Thompson proposed using Northerly Island for a downtown airport, but it was not until 1935 that the City Council authorized construction. The airport opened in 1948 and was an immediate hit with private pilots, business fliers, and commuter airlines. The most current closing of Meigs was not the first, but it was the first in which the runway was destroyed. Friends of Meigs Field will always remember it as the "coolest little airport on the planet." (Photo courtesy of Ted Koston.)

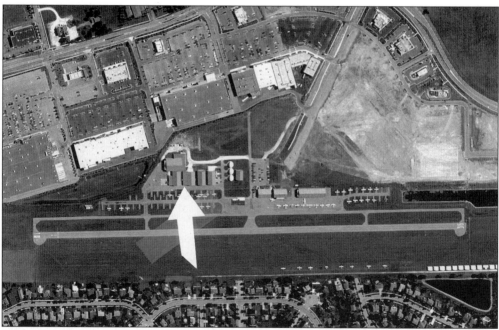

Boyd Clow bought an airplane and parked it in his cornfield along with others that friends were storing there. He named the field Clow International Airport in 1972 so that people would remember the name. The Wright Redux flyer was completed here (arrow) and tested before going to Chicago's Museum of Science and Industry in December, 2003. (Photo courtesy of Joe DePaulo.)

Five

EARLY CHICAGO
AIRLINES

Commercial Airlines were few and far between in the 1920s. Chicago's Heath Airplane Company operated three airplanes for sightseeing and aerial photography in 1925 and Yackey Aircraft Co. of Maywood had a whole fleet of airplanes that carried 2,813 passengers and 8,000 pounds of freight with some cross country flight. By 1927 National Air Transport, Inc. was up and running with 36 planes, 20 of which were Douglas biplanes. Universal Air Lines was flying to six cities from Chicago using three Hamilton metal planes. Their shortest route was to Madison, Wisconsin, which cost $15. Chicago's great United Airlines goes back to the same time period when it was called Boeing Air Transport (BAT), part of a large conglomerate that flew planes as well as made planes. In 1934, Boeing was forced to break-up, thus BAT and three other airlines became United Airlines. Only a few years later, in 1927, the Chicago-New York sector became the busiest air route in the world with Transcontinental, Western Air, American Airlines, and United Airlines flying 25 daily round trips with a total of 500 passenger seats. Airlines profitability depended on more than just filling all the seats; they also transported mail and cargo. For years it was the mail contracts that kept the airplanes in the air.

Cutting edge, new transportation such as the stylish dirigible and the airplane offered services to the public at prices that only the rich and near rich could afford. So, Chicago's amusement parks offered a chance for ordinary citizens to "fly" for mere pocket change in their photograph studios.

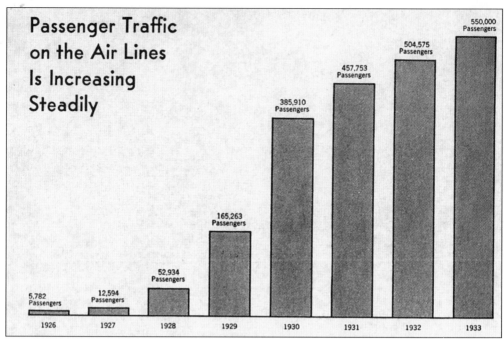

Passenger Traffic on the Air Lines Is Increasing Steadily

5,782 Passengers — 1926
12,594 Passengers — 1927
52,934 Passengers — 1928
165,263 Passengers — 1929
385,910 Passengers — 1930
457,753 Passengers — 1931
504,575 Passengers — 1932
550,000 Passengers — 1933

Even during the damaging years of economic retreat in the early 1930s, passenger traffic on airlines grew at a steady rate. Had the Great Depression not occurred and the airline not been denied further money for research and development, no doubt new airlines would have appeared on the scene much quicker, attempting to keep up with increased customer demand.

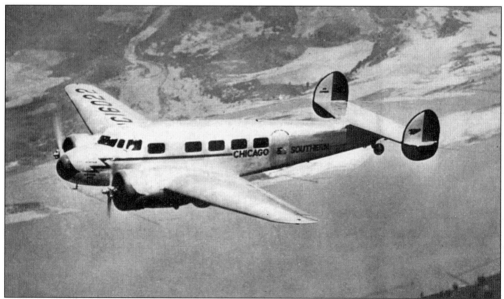

The Great Depression was hard on the airlines, but by the end of the 1930s things began to look up. In 1936, Chicago and Southern Air Lines reported a 164 percent increase in revenue over the year before. This made it possible for them to reduce fares in order to be in line with other forms of transportation and not, "effect the high standard of service and equipment maintenance employed," reported Carleton Putman, president.

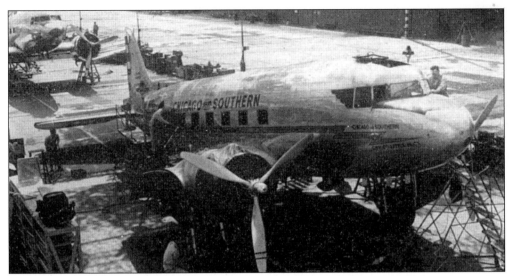

The route of Chicago and Southern Air Lines between New Orleans and Chicago stopped at Jackson, Mississippi; Memphis, Tennessee; St. Louis, Missouri; Springfield, Illinois; and Peoria, Illinois. During World War II, the U.S. Government took over their 21-passenger Dixieliner, shown here. In this photo it is being refitted at the Douglas Santa Monica plant before being returned to the airline in 1944.

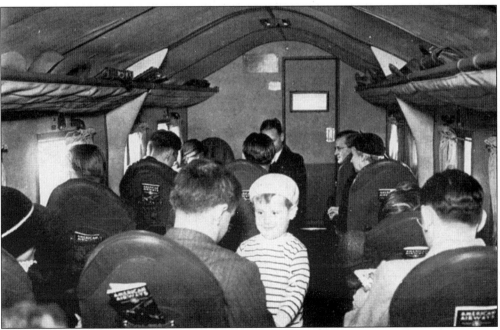

Airliners were getting bigger and bigger, offering passengers more room in 1930, but for tall voyagers the headroom was still tight. This is the interior of a new American Airways Cyclone-powered Curtiss-Wright Condor on its way from New York to Chicago in 1933.

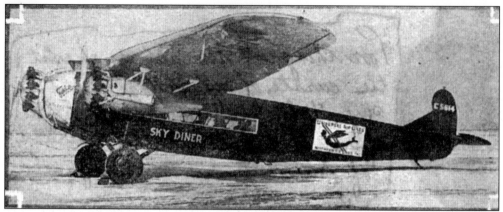

Here is the first of a fleet of 109 "sky diners" in which complete meals were served. This giant airliner named *Miss Cleveland* was owned by Universal Air Lines and made its maiden voyage from Cleveland to Chicago during the week of January 28, 1928. It carried 12 passengers. On board, one could leave Cleveland at 6:50 a.m., have a hot breakfast, and arrive in Chicago at 8:35 a.m.

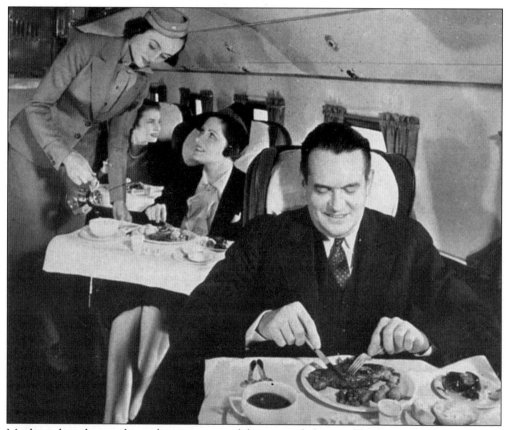

Meals on board super liners became more elaborate with large tables for passengers and food served by friendly stewardesses. These mainliners held 21 passengers in each 12-ton ship made by Douglas. Two 1,200 hp twin-bank 14 cylinder Wasp engines, which could sustain flight at 11,500 feet, powered the liner.

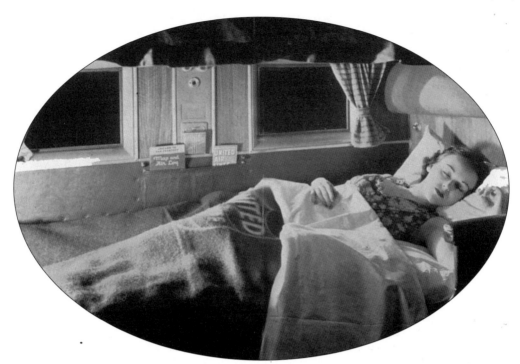

Coast to coast travel was revolutionized with the introduction of United Airlines "Mainliners" that could cruise at 190 mph. They were crewed with "three pilots—two veteran pilots and latest type automatic gyro pilot" and a stewardess. The Mainliners offered sleeper berths as wide as twin beds for those who wanted to arrive at their destination after a good night's sleep.

AIR STEWARDESS
By VIDA HURST

Author of
"NO MAN HER AGE"

To escape the pain of a broken romance, she became a stewardess on a great air-liner. Above the clouds she found new life, adventure, and real love.

BAT made many contributions to the passenger service business. Seven pretty, young nurses under the direction of Ellen Church became the first airline stewardesses in 1930. They were placed on board to "comfort" the passengers. Soon other airlines added this popular feature. This job held a lot of glamour at the time and soon romantic novels filled the bookstores.

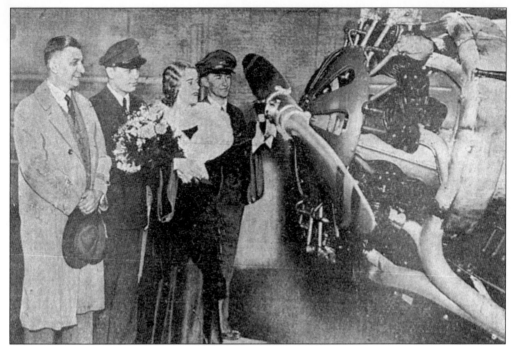

United Airlines expanded their operations at a fast pace in the 1920s and 1930s. Long flights were popular and faster than even the speediest streamliner train. The first United Chicago to San Francisco service is shown being christened. Beside the Boeing tri-motor are, from left to right, Ray Ireland, Chicago District Manager; Dick Petty, pilot; Blanche Underwood, sponsor; and Ken Quayle, pilot.

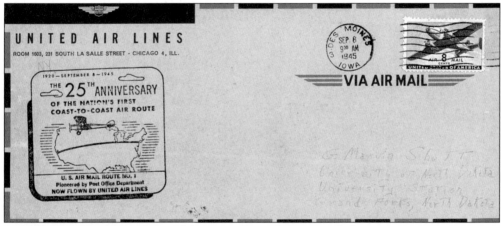

In 1945, United celebrated the 25th anniversary of the nation's first coast to coast air route, which had been called Route 1. The Post Office Department pioneered this route, but in 1934 it was being flown by United. Shown here is the commemorative first day cover issued by United Air Lines, which was based on LaSalle Street in Chicago.

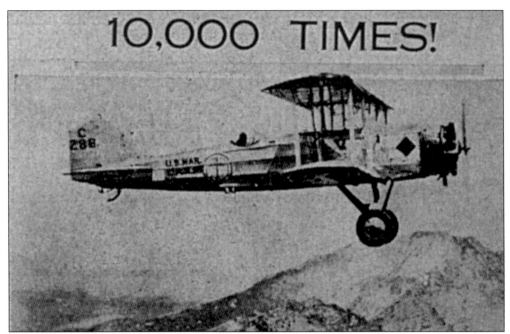

10,000 TIMES!

Only two passengers flew on United's Boeing 40-B-2 during that first coast-to-coast flight in 1927. By 1934 United had completed its 10,000th transcontinental run from New York to Chicago to California. In 1927, the trip took 33 hours; in 1934 it took only 8.5 hours.

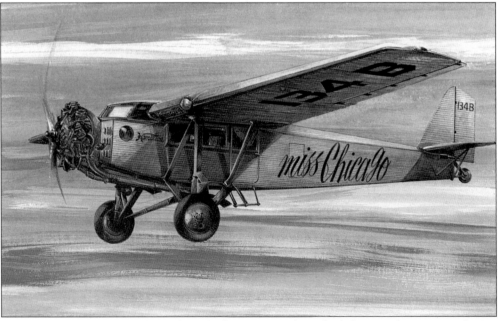

Northwest Airways "Metalplane" dates back to 1926 and was built by Hamilton Aero Mfg. Co. They used a new alloy called "dural." Its designer, James S. McConnell, later became famous for his jet powered fighter aircrafts such as the *Voodoo*. Northwest had eight of these Milwaukee built planes operating on the St. Paul, Minnesota to Chicago route. Here is *Miss Chicago*, a 1928 H-45.

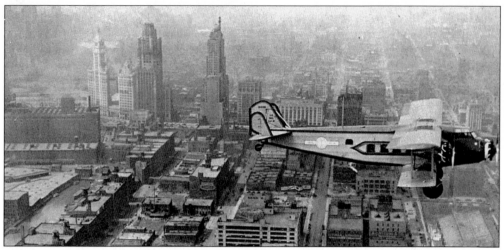

This magnificent view of downtown Chicago shows a Chicago-San Francisco Air Express circling over the city before it takes off for California. It flew to Cheyenne, Wyoming where the crew was changed, then on to California. This north side view shows the Wrigley Building, Tribune Tower, and Medinah Athletic Club.

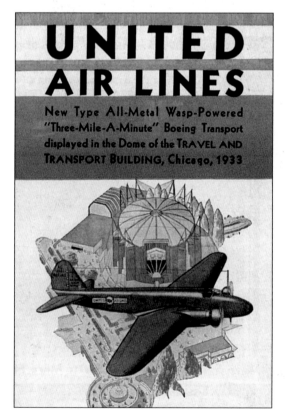

United was at the 1933 Century of Progress Fair in Chicago showing off its new all-metal Wasp engine-powered Boeing Transport. The plane was displayed in the dome of the Travel and Transport Building. At high speed, it could do "three-miles-a-minute" and carry a crew of three with ten passengers, baggage, mail, and express post. The cabin was a modest six feet high.

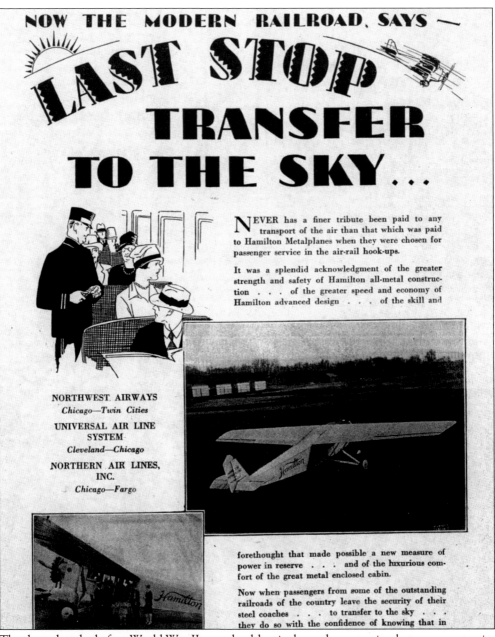

NOW THE MODERN RAILROAD, SAYS —

LAST STOP
TRANSFER
TO THE SKY...

NEVER has a finer tribute been paid to any transport of the air than that which was paid to Hamilton Metalplanes when they were chosen for passenger service in the air-rail hook-ups.

It was a splendid acknowledgment of the greater strength and safety of Hamilton all-metal construction . . . of the greater speed and economy of Hamilton advanced design . . . of the skill and

NORTHWEST AIRWAYS
Chicago—Twin Cities

UNIVERSAL AIR LINE SYSTEM
Cleveland—Chicago

NORTHERN AIR LINES, INC.
Chicago—Fargo

forethought that made possible a new measure of power in reserve . . . and of the luxurious comfort of the great metal enclosed cabin.

Now when passengers from some of the outstanding railroads of the country leave the security of their steel coaches . . . to transfer to the sky . . . they do so with the confidence of knowing that in

The three decades before World War II saw a healthy rivalry and cooperation between companies that offered passenger train service and passenger airplane service. At night, passengers had the comfort of sleeping on a train then transferring the next day to the air. Northwest Airline joined Transcontinental Air Transport, Inc. and the Pennsylvania Railroad in a new venture that was started on September 1, 1928, between Chicago and the Twin Cities and beyond. Technology had created streamliner trains and planes that were sheathed in sparkling aluminum by the 1930s, and they were capable of great speeds. Safety was also stressed. The wing of a typical transport plane was built to withstand six times the strain that might ever happen. It could support the weight of five elephants. Schemes such as linking planes and railroads to transport passengers cross-country never took off. The airline was able to do the job alone.

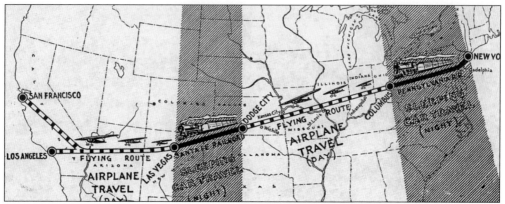

Landing fields had to be found or constructed along railroad right-of-ways to make the coast-to-coast train/plane plan work. Weather reporting stations had to be located every 50 miles along the line of flight so that the pilots could be kept informed within a 50-mile radius throughout the entire route. This 1928 illustration shows the route from New York to California, which included two nights on a train.

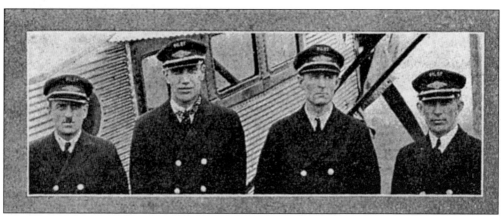

A pilot wrote eloquently, during the era of these Northwestern pilots, about his feelings watching a night mail start for Chicago: "The night was cold and windy, and rain had commenced to fall. I was reminded of a night in France during WW I—when I had sat watching my fellow pilots take off, to kill or be killed. I raised my hand in a farewell salute. His, I thought was a more noble mission." Pictured from left to right are: Homer Cole, John Malone, Walter Bullock, and Fred Wittemore.

Six

MADE IN CHICAGO

"At the outbreak of World War I the United States had 17 planes, 11 in the Navy and 6 in the Army. When the country entered the war in 1917 the Army had 55 planes and the Navy had 54. When the armistice was signed, the Army had 8,396 planes and the Navy 2,107 but less than 800 were in combat areas. The rest were still being made or in shipment," reported the Howard Aircrafter. The fledgling aircraft industry was entering its first boom period.

Chicago was not entirely devoid of aviation activity during the industry's first decade, but the few tinkerers working in the city accomplished little of significance. Probably the most successful were Carl S. Bates, a mechanical engineer who built a few moderately practical flying machines, and Ed Heath, who produced plans so anyone could build his own airplane. More typical of the experimenters of the day was James F. Scott, a scenic artist who built a succession of unsuccessful aircraft. Magazines such as the popular Aero Digest had many artistic ads for airplane companies but many of the companies didn't last even one year.

Several companies that once manufactured airplanes or airplane parts have since gone away from that segment of the market but they continue to service the aerospace industry today with new products and services. Others, such as Haskelite Manufacturing Corporation are now making products completely unrelated to the aerospace industry.

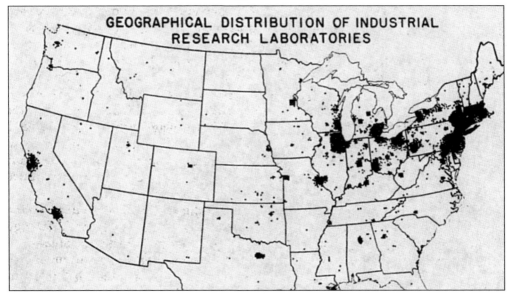

America was a hot bed of industrial research after World War I and continuing well into the new century. This map shows where the laboratories were located as of 1940 with each dot representing one laboratory. The National Research Council published the map in 1945. In 1920, the Council recorded less than 500 industrial research laboratories that were maintained by businesses. By 1940 there were 2,264.

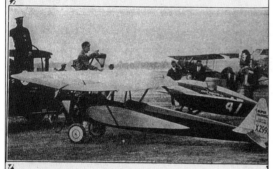

HEATH Sport Planes at the National Air Races

Carried Away Over $2000 in Prize Money

Heath SUPER PARASOLS, America's Most Popular Sport Plane, took 1st and 2nd places as well as a good portion of the prize money.

For four consecutive years Heath Light Planes have won at the National Air Races. They have been leaders for 21 years.

10c in stamps or coin brings our large illustrated booklet.

HEATH AIRPLANE CO.

1721-29 Sedgwick St., Dept. T-1, Chicago, Ill.

Ed Heath was born and raised in New York. He moved to Chicago in 1913 because of all the aviation activity. He opened the E.B. Heath Aerial Vehicle Co. and sold parts for those airplane manufacturers in the city. Heath's Parasol airplanes were made famous by Heath's winning the National Air Races in the mid 1920s.

Heath began advertising Parasol kits for others to build their own airplanes in 1927. Hundreds of blueprints and dozens of kits were sold, but the Heath factory actually made very few to be sold as completed airplanes. Heath advertised his kits in magazines such as *Popular Aviation* and *Aero Digest*.

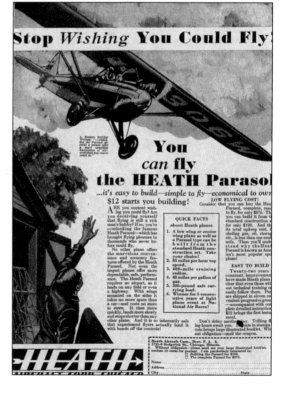

The Aero Model Company at 111 N. Wacker Drive, Chicago made model airplane kits for those who liked flying but couldn't afford a "real" airplane. This ad is for skis so that you could fly the plane in winter weather as well as summer. Richard E. Byrd who flew over the North Pole in 1926 inspired the skis, which became a popular option.

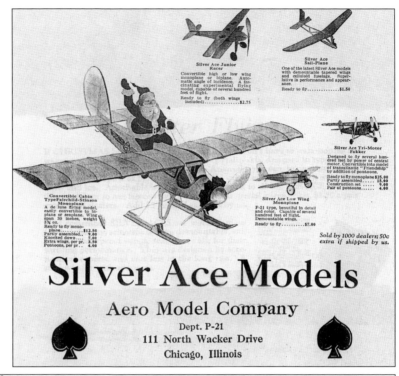

Gliding was the first popular aerial sport. Gotha Glider Company, located at 737 S. Clark Street, sold blueprints for the glider shown here. Chanute once said, "Aviation is a sport. To think of it in terms of commerce is silly." Gliding continues to be a sport, but Chanute was certainly wrong about commercial use of airplanes.

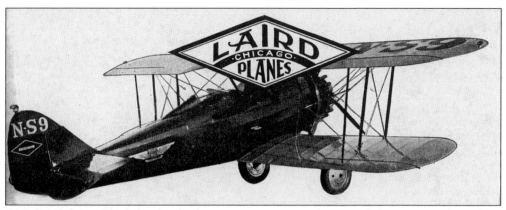

E.M. (Matty) Laird built his first biplane in 1912. In 1923, he started the E.M. Laird Airplane Company at Chicago's Ashburn Field at 4500 W. 83rd Street. Laird airplanes were built for the commercial buyer who wanted high efficiency and dependability and for those whom cost was not a deciding factor.

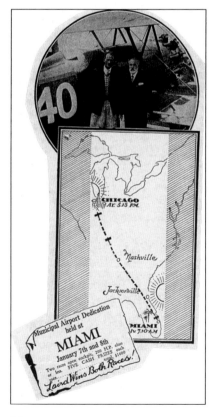

After winning two 800 cubic inch races in Miami, pilot Ballough and passenger Charles Dickinson returned to Chicago in the record time of 9 hours and 59 minutes actual flying time and 11 hours total time. They were flying a Laird-Whirlwind L C-R plane that had been built at the Laird facility at Ashburn Field.

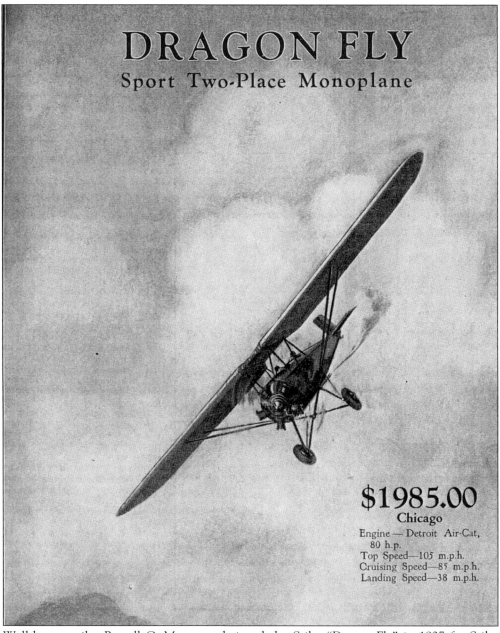

DRAGON FLY
Sport Two-Place Monoplane

$1985.00
Chicago

Engine — Detroit Air-Cat, 80 h.p.
Top Speed—105 m.p.h.
Cruising Speed—85 m.p.h.
Landing Speed—38 m.p.h.

Well-known pilot Russell C. Mossman designed the Stiles "Dragon Fly" in 1927 for Stiles Aircraft, Inc. to fill a demand for a medium priced, fast, new construction monoplane. The engine was a Detroit "Air-Cat" air-cooled engine, and the wingspan was 36 feet. Folding wings were optional. The fact that the plane only used five gallons of gasoline and one pint of oil per hour while running at full throttle was featured.

This plane was designed for ease of maintenance so that the owner-pilot could care for it himself. When the plane was announced, it was said that every part of the engine could be reached from the ground without difficulty.

The first planes to be manufactured were ready for delivery sometime after January 1928 in a facility that occupied 20,000 square feet of factory space in Chicago.

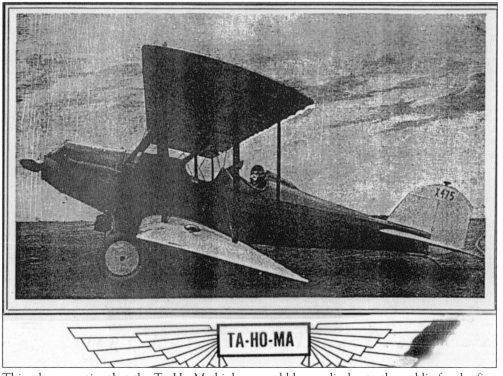

This ad gave notice that the Ta-Ho-Ma biplane would be on display to the public for the first time at the All American Aircraft Show in Detroit, April 6 through 14, 1929. Just like most other manufacturers, Ta-Ho-Ma proclaimed its latest up-to-the-minute safety features. Prominent among this plane's features was the all steel tube system of controls. The Ta-Ho-Ma Aeroplane and Motor Co. was located at 64 W. Randolph in Chicago.

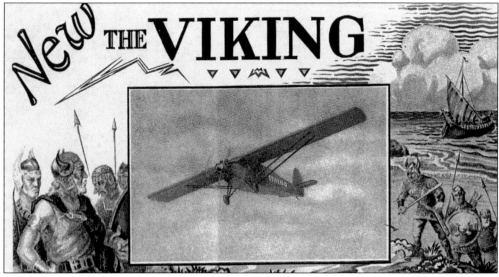

Leon Morgan, who was the president of Viking Aircraft, stressed the strength of his airplane in this ad. The company didn't last long. Viking Aircraft Company was located at 745 S. Clark Street, Chicago until bankruptcy closed in October of 1928.

Manufacturers who made parts for airplanes were scattered all over Chicagoland. Haskelite Manufacturing Corporation found a way to mold plywood into any shape and began making plywood products in 1917 at 129 S. LaSalle Street in Chicago. Airplane manufacturers used their product because it was a lightweight structural material, dependable, and weatherproof. It was also used in boats and automobile door panels.

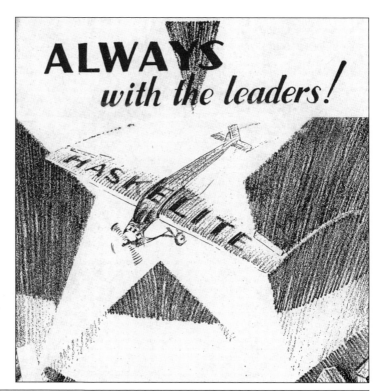

Early airplanes were very noisy. In 1929, Dry-Zero Corporation, located at 130 N. Wells Street, manufactured a lightweight blanket to be put in the walls of an aircraft to insulate against cold and deaden the roar of the engines. This ad tells of the testing of Dry-Zero's insulation performed by the U.S. Bureau of Standards. Note the wicker chairs used to reduce weight.

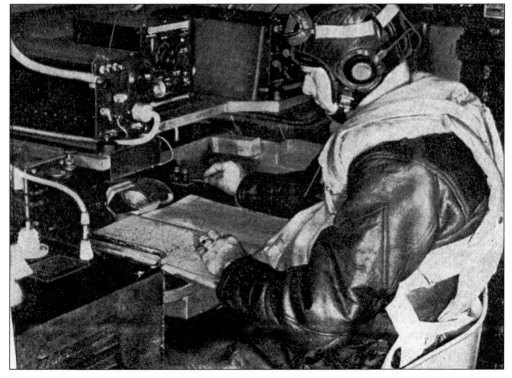
Touroplane Corporation was an unincorporated company that liked to use flights of fancy for their ads. By 1928 the company was owned by Wallace Aircraft Co. in Chicago, but in 1929, Wallace merged with American Eagle in Kansas City, Kansas. A later merger brought the company into the American Airlines fleet.

Norman Rauland was an inventor and radio enthusiast. In 1924, he began broadcasting over station WENR in Chicago. His company, Rauland Corporation, manufactured radios, sound systems, and communications equipment. In the late 1930s, he supplied communications and radar equipment to the government. This ad for airplane communications ran in 1944.

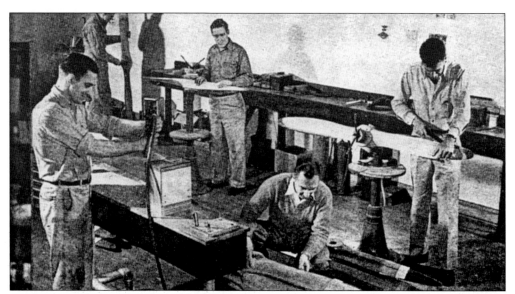

Snyder Aircraft Corporation was located at Municipal Airport as well as in Denver, Colorado and Columbus, Ohio. Employees of Snyder serviced, overhauled, and repaired airplanes. This photo shows employees repairing and servicing wooden propellers.

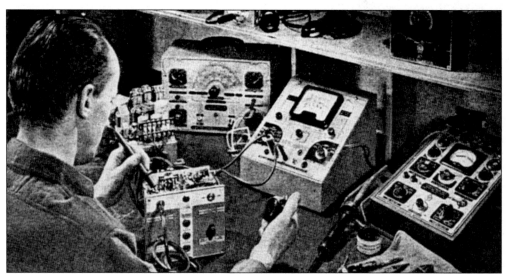

This Snyder employee is servicing an airplane radio. Snyder carried a large inventory of over 15,000 parts from all the "big" names in the aircraft industry so that there would very little down time when plane parts needed servicing or repairing.

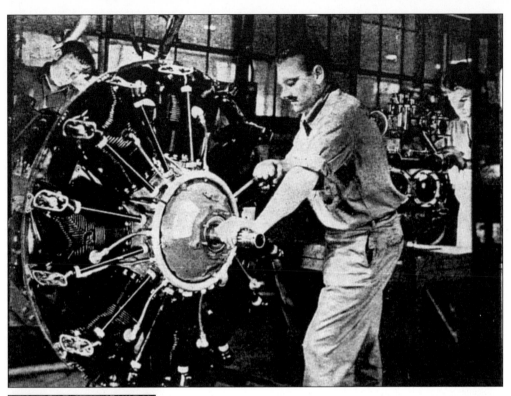

Snyder advertised that they were the only organization in the Midwest that had the facilities and skilled manpower to work on all parts of a plane at once. Here the repairman is working on an engine.

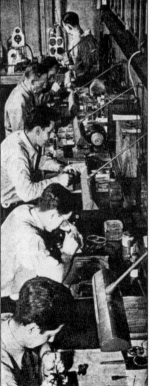

These Snyder repairmen are working in the Instrument Shop. Final testing of the serviced parts was done under flight-simulated conditions. Pictures on these two pages were shown in a 1944 advertisement in *Aero Digest*.

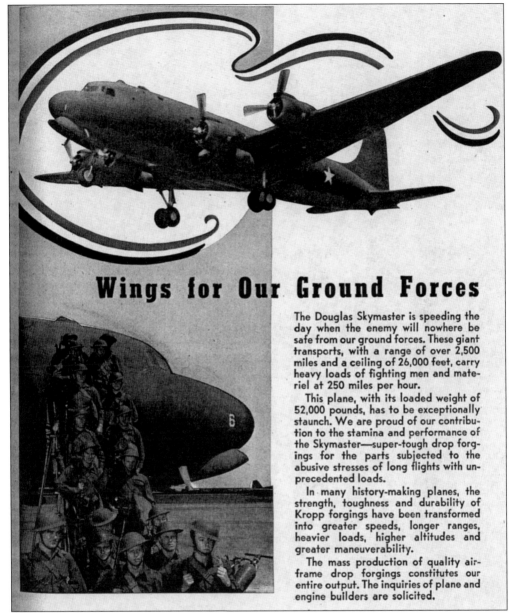

Wings for Our Ground Forces

The Douglas Skymaster is speeding the day when the enemy will nowhere be safe from our ground forces. These giant transports, with a range of over 2,500 miles and a ceiling of 26,000 feet, carry heavy loads of fighting men and materiel at 250 miles per hour.

This plane, with its loaded weight of 52,000 pounds, has to be exceptionally staunch. We are proud of our contribution to the stamina and performance of the Skymaster—super-tough drop forgings for the parts subjected to the abusive stresses of long flights with unprecedented loads.

In many history-making planes, the strength, toughness and durability of Kropp forgings have been transformed into greater speeds, longer ranges, heavier loads, higher altitudes and greater maneuverability.

The mass production of quality airframe drop forgings constitutes our entire output. The inquiries of plane and engine builders are solicited.

Kropp Forge had its Chicago beginnings when Charles A. Kropp and three business associates opened a small forge shop in 1901 that produced flat die work on three small hammers. Kropp became the sole owner before World War I and moved to a Roosevelt Road location in 1918.

Kropp Forge supported the war effort during World War I with products for armaments. This ad featuring the company's involvement in aviation shows that they were still producing war related materials during World War II, materials such as planes, ordnance, ships, military vehicles, and other essential machinery.

The Kropp family sold the business in the late 1970s, but the business still flourishes at 5301 W. Roosevelt Road. Today, the aerospace industry continues to dominate the company's work. Currently, some of their major customers are Boeing, Lockheed Martin, Olympic Aviation, and Bell Helicopter.

PRECISION FABRICATORS OF PLASTICS FOR INDUSTRY

LASTI-GLO MANUFACTURING CO.
1832 IRVING PARK ROAD, CHICAGO 13, ILL.

Plasti-Glo FABRICATORS

Plasti-Glo Manufacturing Corp. located at 1832 Irving Park Road, Chicago, developed its own "war related" advertising in 1944. They were looking for new products and advertised, "If your part or product presents exceptional manufacturing problems or requires close tolerances, consult us!" Today Plasti-Glo makes aircraft windshield plastic polishes and cleaners, among other products, in Los Angeles.

"Gosh, Dad, can birds ever fly this high?"

INSTRUMENTS BY
STEWART-WARNER CORPORATION
CHICAGO STEWART WARNER ILLINOIS

The Stewart-Warner Corporation made instruments for airplanes as well as automobiles, power boats, and industrial engines. Their instruments were put in a "dashboard" to tell a pilot all he needed to know at a glance. This 1944 ad featured travel in "the family plane of tomorrow."

82

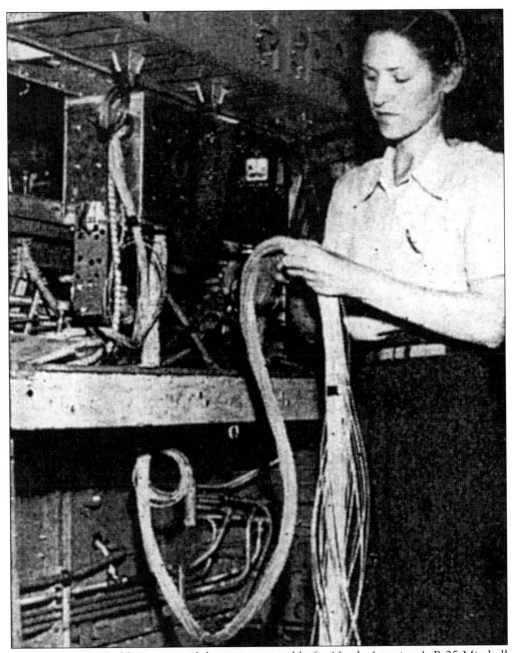

This employee is holding a part of the wiring assembly for North American's B-25 Mitchell Bomber. Belden Manufacturing Company at 4691-A W. Van Buren Street in Chicago made this assembly during WWII. Belden manufactured airplane ignition, lighting, and power systems during WWII. Belden wire was also used for bonding purposes through the wings and fuselage to form the antenna system at this time.

Joseph Belden founded Belden Manufacturing Company in 1902 and emphasis has always been on quality since his initial interest in manufacturing wire came about because he had trouble finding high quality silk insulated magnet wire. Belden, although still in business, closed the Chicago plant in 1976.

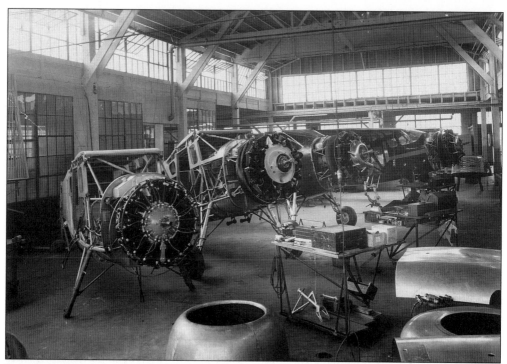

Ben Howard built his first airplane in 1925 as a sport plane. The first Howard cabin airplanes built for commercial purposes were completed in 1935. This 1938 photograph of motors and a partially completed airplane was taken in the Chicago Howard plant.

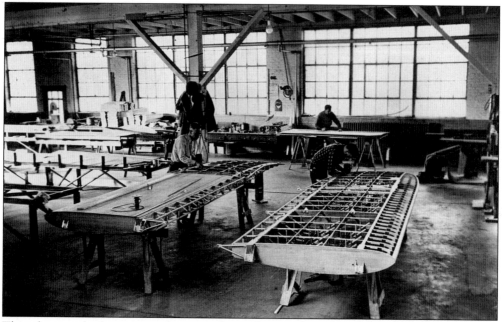

This photograph shows wings being made in the woodworking department of the Howard Chicago plant. Wings were built of spruce then covered with plywood. The plywood was covered with fabric, and then finished with dope to make a slick, smooth surface.

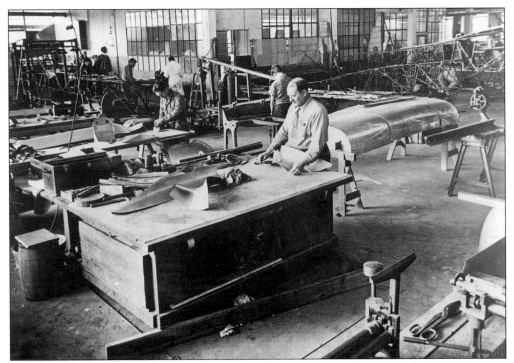

In this general view of the Howard sheet metal department, notice how the manufacturing plant looks a lot like a very large workshop rather than a modern, streamlined factory. Assembly line work was not the standard before World War II.

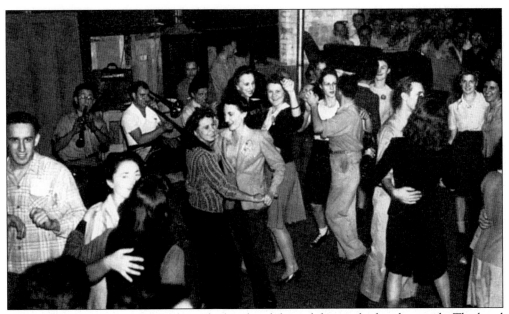

These 1943 Howard employees formed a band and danced during the lunch periods. The band was made up of Robert Krenek, Pat Trapaini, Frank Raimondi, Ed Santini, Walter Blum, Paul Skodacek, and Hubert Ashley. What a wonderful diversion from assembly line work! Howard's St. Charles plant had a similar band for the employees.

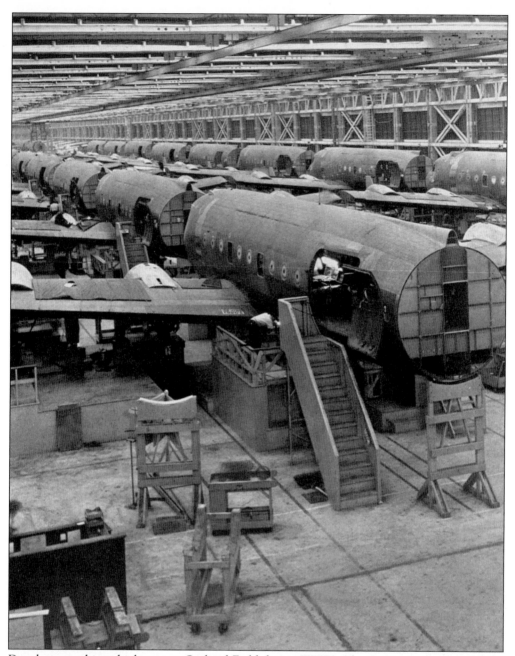

Douglas moved into high gear at Orchard Field during WWII. The C-54 was developed from the DC-4, a 4-engined, 52-passenger airplane that was powered by Pratt and Whitney Twin Hornet 1150 hp engines. It was refitted to be a long range transport plane to carry airplane parts, blood plasma, medical supplies, food, and munitions to the fighting fronts, then to serve as a hospital on the return flight.

When the wing was fully assembled, it was composed of five panels with an overall span of 117 feet 3 inches. In this picture of the Douglas factory, you can see that the wings are not yet fully assembled, giving space for two lines of production in the building. The first C-54 was put in service only 12 weeks after the U.S. entry into the war.

Seven

HOLLYWOOD SELLS AIRPLANES

Wallace Beery was born on April 1, 1855, in Kansas City and died on April 15, 1949 in Los Angeles. He was a big man with enough charm and charisma for a dozen men. He was a one-of-a-kind guy who became one of Hollywood's greatest actors. One of his first films as an actor, called Mr. Dippy Dipped, was made in 1913. All in all he made 217 films before his death.

Beery excelled in roles that required no fancy acting. He always said that he was not acting but simply playing himself, an average American guy. Yet he brought to all his roles quite vivid characterizations. Who could forget watching Beery as Long John Silver in Treasure Island, which was made in 1934?

Beery's private life was as interesting as his work on the screen. His career had its ups and downs, but all of his life he had a passion for flying. Like many who fly and fall in love with planes, he owned a lot of them in his lifetime, but he finally settled on one company and its planes to own and champion. The company was Howard Aircraft, a famous Chicago manufacturer whose founder, Benny Howard, had the same kind of life attitude as Wallace Beery. Beery spoke bluntly and often; Howard did likewise. Howard planes carried lettering and numbers such as DGA 9. The three letters on a Howard plane are reputed to stand for "Damned Good Airplane."

This chapter will play tribute to Wallace Beery, actor and navy aviation cheerleader, and his struggle in the late 1930s to keep flying new state-of-the-art Howard Aircraft as he acted as the company's most famous endorsee.

This photograph is from Howard Aircraft Corporation's archives and shows some of the most popular of the Howard airplanes that were made for private, non-commercial air enthusiasts. Howard maintained factories in Chicago and St. Charles, Illinois.

It was in a film called *Champ* that Wallace Beery got his one and only Oscar, sharing the honor in 1931 with Fredrick March in *Dr. Jekyll and Mr. Hyde*. M.G.M.'s King Vidor directed the film, and a youthful and talented Jackie Cooper was in the cast.

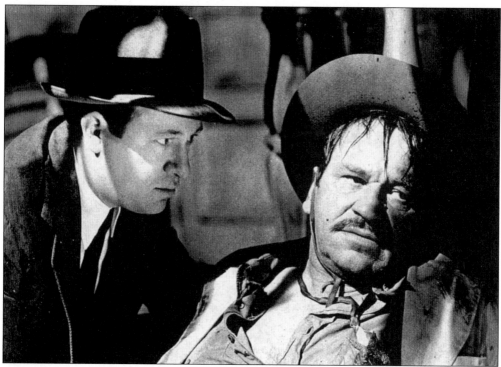

Beery turned in one of finest screen roles as Pancho Villa in the file *Viva Villa!* made in 1934. For an actor who always walked the fine line between being taken seriously or simply an old-fashioned silent screen comic, his realistic portrayal of Villa was a major triumph.

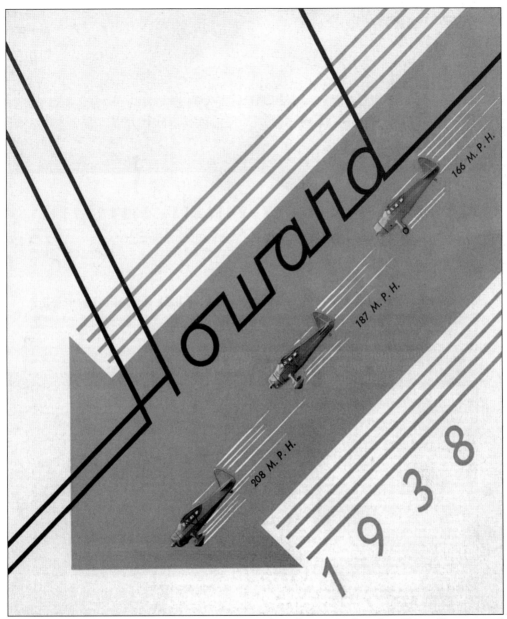

It was easy to see why Wallace Beery liked Howard airplanes. He thought of himself as a rugged man. Howard also thought of his planes as "having a rugged character with no nonsense." The prides of the 1938 Howard Fleet included the DGA 11, which could travel at a cruising speed of 208 mph, the DGA 8, which had a cruising speed of 187 mph, and the DGA 9, with a cruising speed of 166 mph

The DGA 11 was fitted with a Pratt & Whitney Wasp Jr. 450 hp engine, used 80-octane fuel, and cost $17,685. The DGA 8 had a Wright Whirlwind R760-E2 320 hp Radial Air-cooled engine and also used 80-octane fuel. Completely loaded, it cost $14,850. His DGA 9 used 73-octane fuel and was powered by a Jacobs L-5 battery ignition 285 hp engine and cost a modest $9,880. The DGA 12 joined the lineup in 1939. It was a 187 mph cruiser equipped with a Jacobs L-6 battery ignition 300 hp engine which gave it a range of 1,085 miles on a 97-gallon tank.

Howard Aviation was proud of the fact that the Civil Aeronautics Authority in Washington D.C. owned four Howards. These planes were used to go around the country to crash sites for inspections. The fact that Howard planes were picked for these missions showed the government's respect for DGAs.

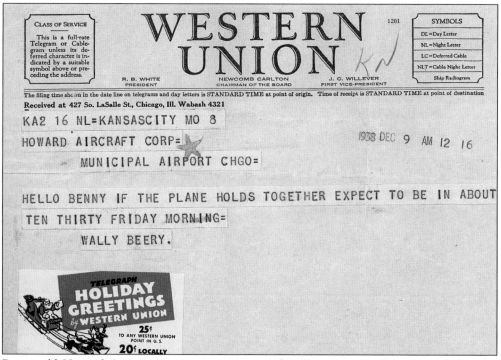

Beery told Howard Aviation on many occasions what "improvements" were needed to his Howard aircraft. "What do you think of a little more power on the nose of the Howard?" when also noting that he was averaging "185 mph per hour at thirteen thousand feet wide out which is about 65 percent power—which I think is pretty good." Wires flashed back and forth between Beery and the Howard factory in Chicago.

Mr. Wallace Beery, noted actor, sportsman, hunter and veteran flyer is shown in characteristic attitudes with his DGA-11 Howard, powered with a [Wasp?] 450 H.P. engine, reminiscent of his [...] in "Bad Man of Brimstone", "RUGGED-is THE WORD FOR IT", "Stand up & Fight" and many other cinema hits. Mr. Beery flies a Wasp Jr. powered Howard

It is interesting to see the creative juices flowing in this scrap of paper from someone in the advertising department at Howard Aviation where they are working out the exact wording of a Beery ad. Note the idea to describe Howard aircraft as "RUGGED-is THE WORD FOR IT."

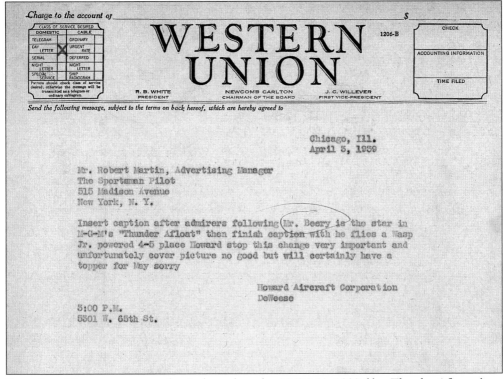

Beery lent his name to not only airplanes but also M.G.M.'s 1939 film *Thunder Afloat* where Beery played the lead named John Thorson. Beery also made two other films that same year, *Sergeant Madden* and *Stand Up and Fight*, all of which were wartime propaganda efforts.

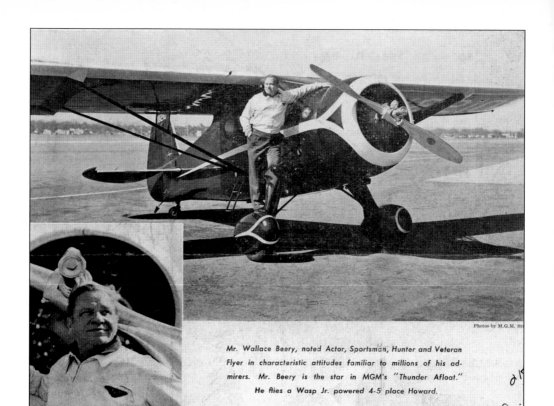

Photos by M.G.M. Sti

Mr. Wallace Beery, noted Actor, Sportsman, Hunter and Veteran
Flyer in characteristic attitudes familiar to millions of his ad-
mirers. Mr. Beery is the star in MGM's "Thunder Afloat."
He flies a Wasp Jr. powered 4-5 place Howard.

"RUGGED is the name for it"

The Howard for 1939 lives up to its heri-
tage. Designed by men who know the
hazards at the Pylons, their stamp is indelibly
marked on every vital part for the guidance
of an experienced factory personnel headed
by one of the safest Builders in the Industry.

Inbuilt RUGGEDNESS obtained without ex-
cessive weight results in MORE useful load
with LESS gross weight and areas, consequent-
ly the Howard is FASTER with better takeoff
and landing abilities than any plane of its
type equipped with equivalent horsepower.

TAKE A LOOK AT HOWARD FOR 1939

Howard AIRCRAFT CORPORATION
5302 WEST 65th STREET, CHICAGO, ILL., U.S.A.

After months of letters and telegrams between the advertising office at Howard, M.G.M.
Studio, and Wallace Berry, the studio signed the proof copy on April 6, 1939 for an
advertisement scheduled for the April 15 issue of the *Sportsman Pilot*. This ad contains elements
necessary to satisfy all parties. Berry selected the studio pictures he liked. The studio got a plug
for a movie. Howard got a picture of the Wasp Jr. being hugged by a famous macho movie star
and copy stressing that the planes are rugged, useful, light, and fast.

CULVER CITY, CALIFORNIA

. The undersigned, LOEW'S INCORPORATED, a Delaware corporation, hereby gives and grants to **Howard Aircraft Factory** , the right to use in the United States and Canada only, the name and photograph of_____ **Wallace Beery** upon the following terms and conditions:

 1. Said name and photograph are to be used only in advertising and publicity issued in connection with_____ **Howard airplanes** and must carry the credit line of Metro-Goldwyn-Mayer whenever used.

 2. Proofs of all advertising and publicity using said name and/or photograph must be submitted to the undersigned for approval before being used and may not be used until approved in writing by the undersigned and may be used only in the form approved by the undersigned.

 3. The right herein granted shall terminate **12 months from date**

Dated this **21** day of **March** , 193 **9** .

 LOEW'S INCORPORATED
 By
 HOWARD STRICKLING

The undersigned hereby agrees to comply strictly with each and all of the terms and conditions hereinabove set forth.

Dated this **21** day of **March** , 193 **9** .

I hereby consent to the use of my name and photograph in accordance with the foregoing terms and conditions.

Dated this **21** day of **March** , 193 **9** .

Beery and his studio were sticklers for approval to use pictures of the star and required that they authorize all ad copy as well. Annual contracts such as this one had to be signed each year by all three parties before a deal was struck. Berry was an active flyer and a fan of Howard planes so his endorsement of their planes was genuine. He hopped all around the country with his two daughters. Berry held a commercial pilot's license. By 1941 he had 7,000 hours of flying time. On occasions he was known to go into a factory and tell the workers to do a good job on the plane being assembled because it was his, and it had to be right.

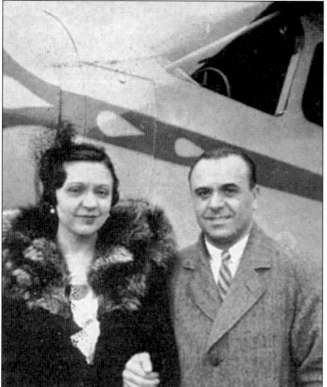

Wallace Beery was not the only famous person recruited to sell Howard aircraft to the public. Heads of oil companies, car company executives, and paint manufacturers were all willing to have their pictures taken beside their planes to be included in company sales brochures. Mr. Carleton Putnam, president of Chicago and Southern Air Lines, Inc. is shown here.

Famous musicians such as Miss Ampara Iturbi and Mr. Jose Iturbi, world famous Spanish pianists living in New York, had a Howard. They are shown here with their new airplane. Jose Iturbi was also a world-class orchestra conductor and a movie star.

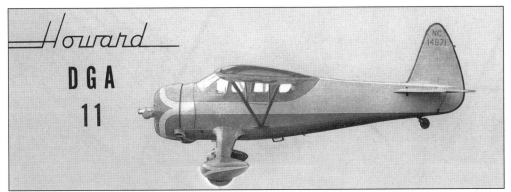

Howard

D G A 11

Wallace Beery's DGA11 was to be a doozie. He got quite a deal, trading in a Stinson plane for $12,685, making a $1.00 deposit and paying $4,999 upon delivery. A Model DGA 11 sold for $17,685. The sales contract of June 28, 1938 showed several extras including an automatic valve oiler and a golf bag extension in the rear of the baggage compartment.

The DGA11 was painted solid maroon with Diana Cream trim and numbers with suitable pin stripes. "Wallace Beery-Hollywood" was painted in 2 inch letters near the nose and both sides under the pilot's window. The cabin had red leather seats and brown sidewalls. Also included was an extra 30-gallon tank, filler neck in the rear tank, headphone jacks for all seats, and suction pumps for Horizon and Gyro.

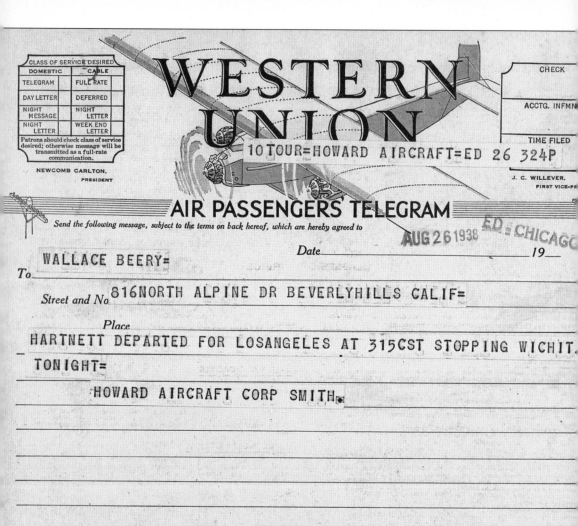

WESTERN UNION

CHECK

ACCTG. INFMN

TIME FILED

10 TOUR=HOWARD AIRCRAFT=ED 26 324P

J. C. WILLEVER.
FIRST VICE-PF

AIR PASSENGERS TELEGRAM

Send the following message, subject to the terms on back hereof, which are hereby agreed to

AUG 26 1938 ED = CHICAGC

Date_____ 19___

To WALLACE BEERY=

Street and No 816 NORTH ALPINE DR BEVERLYHILLS CALIF=

Place

HARTNETT DEPARTED FOR LOSANGELES AT 315CST STOPPING WICHIT.

TONIGHT=

HOWARD AIRCRAFT CORP SMITH.

THE QUICKEST, SUREST AND SAFEST WAY TO SEND MONEY IS BY TELEGRAPH OR CABLE

Victory! Beery got his DGA11 in late August of 1938. Although he flew other makes of planes in his lifetime, Berry was a staunch Howard Aircraft supporter. "The Howard is about the only fast single motor job that has not been placarded to date so slip ahead of Beech Craft and Waco while the going is good," he wrote on one occasion.

Throughout the years Beery remained on good terms with Howard even though many angry letters were written to the factory. On another occasion, when he was without a plane, he wrote a short note loaded with curse words to his "pals" at Howard.

Eight

THE AEROSPACE AGE

The Aerospace industry depends heavily on manufacturers in the Chicagoland area to keep it supplied with components and cutting edge new technology. Amazingly, some of the sub components developed for aviation almost a hundred years ago such as gears, motors and wire have a modern counterpart.

Factories in the greater Chicago area are kept busy producing such essential aeronautical parts as gears, LED lights, ducting, motors, wire, cameras, and displays. Many of the aerospace companies in Chicago are old-line manufacturers who joined the industry when it first began to emerge following World War II.

Others came on board in the 1970s, 1980s, and 1990s as new technology evolved out of research and development, which demanded, in turn, new products. Boeing's recent move to Chicago has placed them firmly as one of the leading forces in Chicago's aerospace industry. Boeing, the nation's largest exporter, is a global leader in missile defense, human space flights, and launch services. The companies represented in this chapter provided all of the photographs.

A good many smaller aero businesses are in buildings such as this laboratory of Falex, although there are some very large manufacturers of aerospace products in the Chicago area that use large facilities. Don't let the size of the building fool you, however. These high tech firms are doing big business, making small, essential parts for the aerospace industry.

Arrow Gear began making gears in 1947, and in 1952 added aerospace products to their inventory with products such as jet engine accessory drive gears. Arrow Gear, in Downers Grove, makes more jet engine accessory drive gears than all other gear makers in the world. Machinist Stanley Remiasz is preparing to grind the inside diameter of a gear in this photograph.

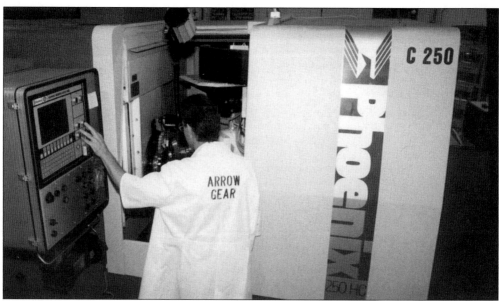

Here, Jay Metzcher is setting the coordinates to start the grinding operation in order to make a bevel gear. The majority of work at Arrow Gear is loose gearing for a diverse range of customers. Arrow Gear is known world wide as precision manufacturers of sophisticated gears. Arrow Gear made the sprockets for the Wright Redux project featured in the final chapter.

Micro Lamps began manufacturing miniature lighting products for the aircraft, avionics, automotive, and electronics industries in 1975. Vinay Prakash, manager of quality assurance and technical services, is testing the illumination of an aircraft navigational light in the Batavia lab. The lamp is mirrored on one side so that more light is thrown forward.

Micro Lamps employee Glenn Carlson is testing one of Micro Lamps halogen products. The in-house engineering services are capable of designing and building special application semi-custom lamps for their customers. Their based LEDs are used as pilot lights, as indicators and in pushbuttons.

Michael Van Horne and Andy Kozlowski of A.M. Precision Machining, Inc. in Elk Grove Village are inspecting the internal diameter of a jet engine fuel nozzle. A.M. Precision Machining, Inc. was established in 1983 to service the aerospace industry and other industries that required precision machining. AMP manufactures fuel nozzles, valves, duct seals, and other hydraulic components for the industry.

Margaret K. and Michael Van Horne are comparing the fuel nozzle to the specifications. AMP is a small woman-owned and family-operated ISO-9002 certified machine shop that provides products for companies such as Boeing, Parker Hannifin, and Goodrich. AMP is one of the many woman-owned businesses in the Chicago area.

Falex Corporation, located in Sugar Grove, offers a complete line of tribology test equipment and services for the evaluation and study of lubrication, friction, wear, and abrasion, and has done so for over 70 years. This photograph shows their lab. Frederic "Fritz" Faville built a machine to demonstrate the wear resistance and friction-reducing properties of the lubricant additives that he sold. His grandson, Andrew Faville, currently runs the company.

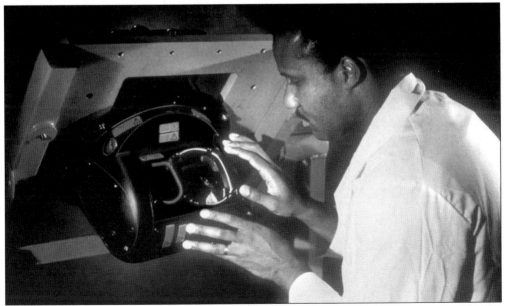

Northrop Grumman, a California based company, has manufacturing facilities all over the world. One of their electronic system facilities is in the Chicago suburb of Rolling Meadows. Northrop Grumman's electronic systems business sector is a leading designer, developer, and manufacturer of a wide variety of advanced defense electronics and systems. Ian Agard is shown here with the AN/AAQ-24 NEMESIS directional infrared countermeasure system (DIRCM), which protects aircraft from shoulder-launched infrared missiles.

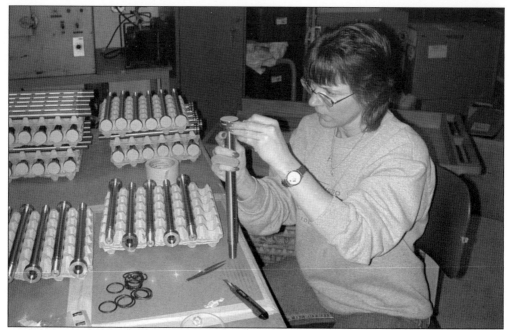

Scot Incorporated, founded by Glen Graham in his Oak Park basement in 1942, designs and manufactures small precision electric motors used in the general aviation field as well as explosive actuated devises and escape systems. This Scot employee is assembling some of the stage separation components for the Delta IV Launch vehicle in the Downers Grove plant.

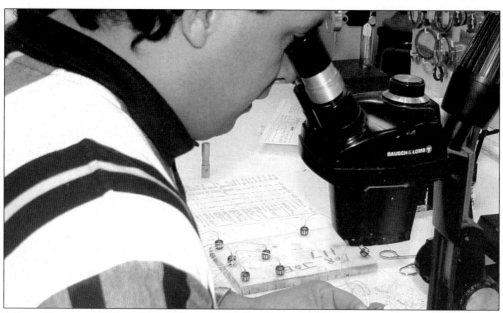

Albert Khant purchased the synchros and other wire wound components from Scot, Inc. in 1990 to do business under the name Scot Electrical Products. These products are manufactured in Aurora for anything that flies, from small pleasure airplanes, to helicopters, to smart bombs, to military jets, to commercial airplanes. Some parts are so small that here, a microscope is used to help the employee Alberto Riscos inspect one of them.

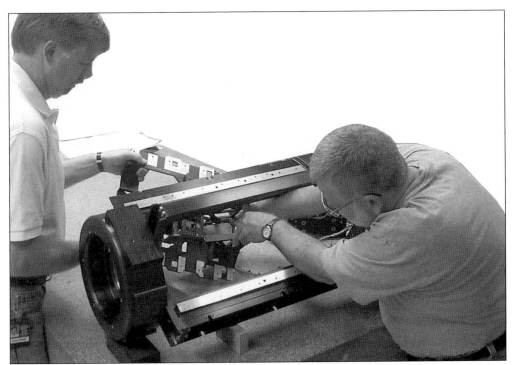

Recon/Optical, Inc. (ROI), operating in Barrington and in the Chicago area since 1922, produces sophisticated reconnaissance camera systems and stabilized weapon mounts for the U.S. Government and its allies around the world. ROI employees produce, integrate, and test the cameras designed and developed by ROI engineers.

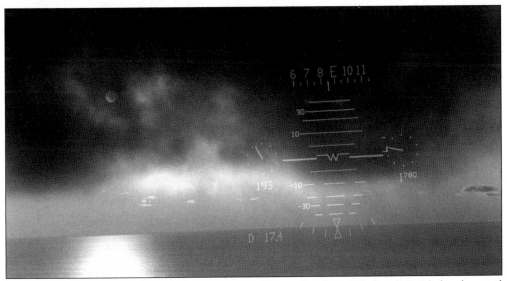

Flight Visions, Inc. was formed in 1986 to develop a Head-up Display (HUD) for the civil market. This photograph shows a view of Lake Michigan shortly after sunrise in winter with the HUD projected on the window. The symbology shows that the plane is heading east at a speed of 193 knots and at an altitude of 1780 feet. Using the HUD means that the pilot does not need to shift eyesight from the instrument panel to the horizon.

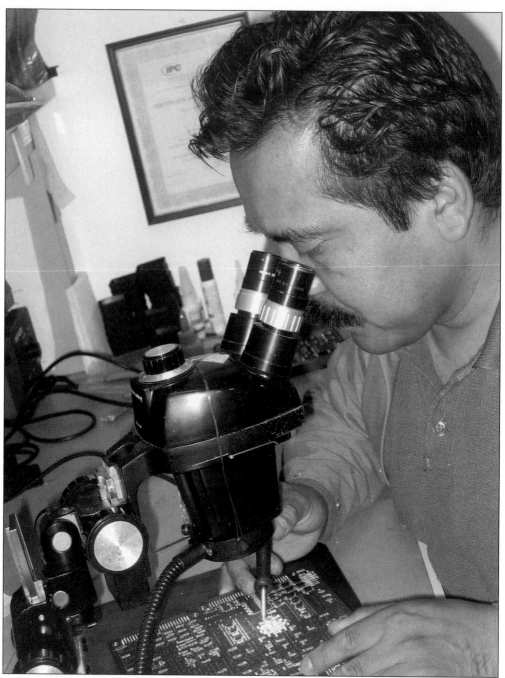

In 2002, Flight Visions, Inc. became a subsidiary of CMC Electronics. Employee Dan Sherman is checking a Head-Up Display for accuracy in this photograph. The company found a better market in the military shortly after it began producing HUDs. Flight Visions employees over 100 people at the Aurora Airport in Sugar Grove and has sold its displays and flight computers to the U.S. Navy when the F-14 was being upgraded. It participated with Lockheed Martin in the Joint Strike Fighter program for the U.S. military. This was the winning aircraft in a government competition, and the aircraft will go into production around 2010.

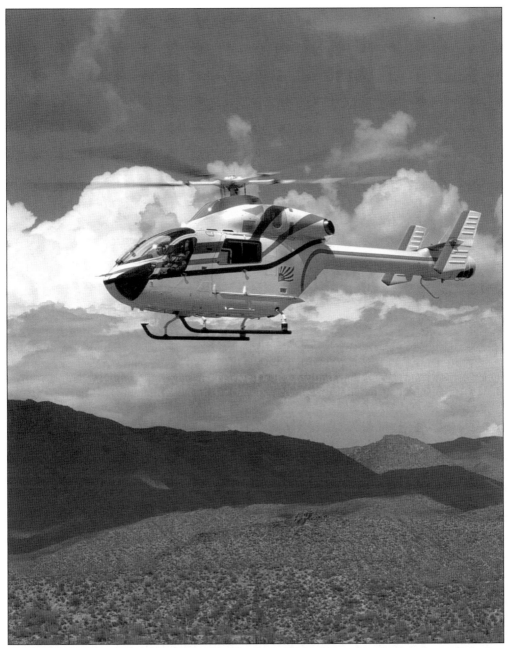

Stanley Tesler likes helicopters! But when he began flying them, he wanted air conditioning, more room, and the ability to go farther on a tank of fuel. Not available? No problem. He developed what he wanted and found that others wanted the same thing. Tesler opened Fargo Manufacturing, located in Chicago, in 1978 to manufacture these improvements for companies such as Boeing, whose MD 900 Explorer is shown above.

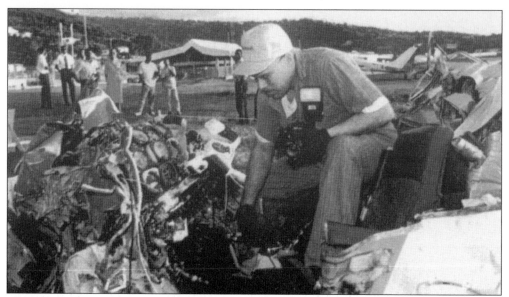

Accident investigation is only one part of the engineering consulting firm of Naperville's Packer Engineering. Employee Don Knutson is shown above during a preliminary investigation in the West Indies. Dr. Ken Packer began developing this multi-faceted, multi-disciplinary engineering company in 1962. Packer volunteered to build the engine for the Wright Flyer featured in the next chapter.

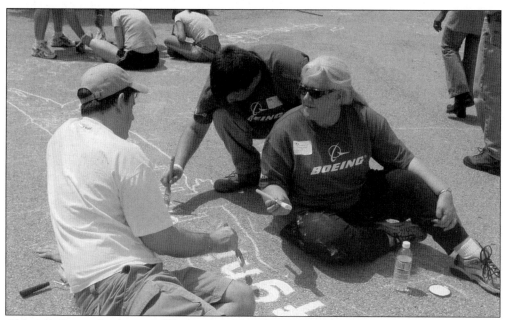

Although Boeing has been in Chicago for only a few years, it is committed to improving life in the city by using its expertise in aero software. A Boeing subsidiary has licensed its Total Airspace & Airport Modeler to the city, which will revolutionize operations at O'Hare. Boeing is also committed to community service. This year, Boeing employees participated in Chicago Cares volunteering for several projects at Richard Yates Elementary School, painting stairways, lockers, and playground murals.

Nine
IT FLIES AGAIN

Tom Norton and Mark Miller began building an airplane just for fun; not just any old plane but a Wright Brothers plane. Neither was a pilot, but they didn't let that stop them. When they found that they would need more funds and expertise than they could provide, they organized the Wright Redux Association in Glen Ellyn, Illinois to finish the project of building a replica of the 1903 Wright Flyer.

The project evolved out of a 2000-01 high school project of Tom's son Peter, who built a glider using plans for the Wright 1900 model. The time was right, 2003 was just around the corner; and besides, no one had been able to build and fly that particular Wright model that flew from the original plans since the Wrights themselves did it. It was just the right kind of challenge for these guys.

Volunteers and funds began to come in. National Geographic and later the History Channel got interested as the project unfolded. The Museum of Science and Industry in Chicago was interested. And then Mark met Dr. Ken Packer of Packer Engineering. And the rest, as they say, is history. In the website dedicated to the project, http://www.wrightredux.org, Chuck Clendenin wrote, "The production of this replica has led to a great show of 'Grassroots Midwestern Volunteerism' at its best." Week by week, progress was charted on the web. And the flyer will hang in the Great Hall of the Museum of Science and Industry after it is flown on the lawn for the celebration of the Wrights' achievement. This certainly qualifies as one excellent adventure! The following photographs were either taking by Packer Engineering (noted by PE) or Chuck Clendenin (noted by CC).

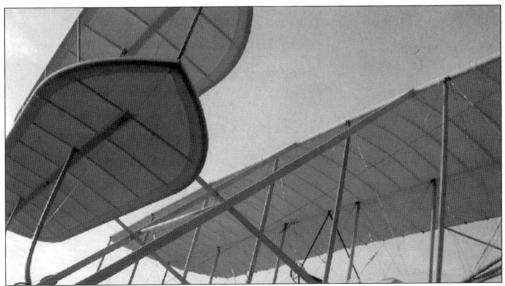

Today, so many people take air transportation for granted. That is only one reason that the Wright Redux team chose to recreate the first Wright Flyer using only materials that were available to the Wrights a hundred years ago. This flyer was built as a tribute to those visionaries going back to Leonardo De Vinci who dreamed of going farther, faster, and higher. (CC)

These Wright plans were used to build the *Spirit of Glen Ellyn*. The wingspan is 40 feet and 4 inches with a double elevator in the front and a double rudder behind the wings. The Wright engine weighed less than 150 pounds and produced 12 horsepower. One of the patents that the Wrights were granted was for a new propeller design. (CC)

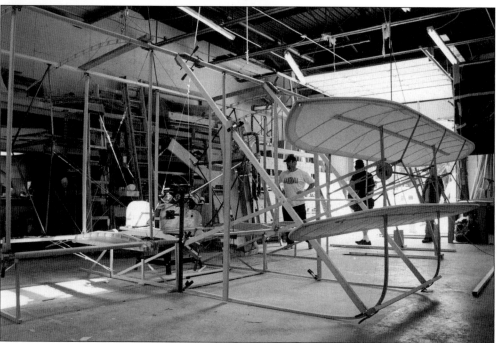

The flyer started out in Mark Miller's woodworking shop in Glen Ellyn in 2001. Just as the Wrights did, Miller used Sitka spruce and ash, which had been donated by Horn Lumber of Chicago, for the frame. Spruce was chosen because it is very straight and has a very tight grain. (PE)

After completing the frame, Mark went to work on the truss wires, which are essential to the integrity and strength of the flyer. The truss wires are bolted in place but they are not tightened until all are attached. As the wires were put on the structure, it began to become rigid. (CC)

In May of 2002 when Mark Miller showed Dr. Packer the engine plans that were drawn by Smithsonian volunteers in 1950, Packer enthusiastically agreed that his firm would fabricate and build the engine for the Wright Redux flyer. A gentleman's hand shake sealed the deal. Packer, who had been a World War II pilot who flew Corsairs in the Marine Corp., appointed John Nowicki, who introduced him to Miller, as project director. (PE)

This photograph of the Packer Engineering team was taken on the day they signed on to the Wright Redux team. Pictured from left to right are Dr. Packer, Steve Meyers, Ed Meyer, John Nowicki, and Patrick McCormick. All are pilots except intern Patrick who is an aviation enthusiast. (PE)

A Channel 7 news team was but one of the many who interviewed those involved in getting the Wright Flyer built and into the air. Here, Dr. Packer is being interviewed about his plans to manufacture an engine to the original Wright specifications. Stories about the Wright Redux project have also been run in newspapers all around the world. (PE)

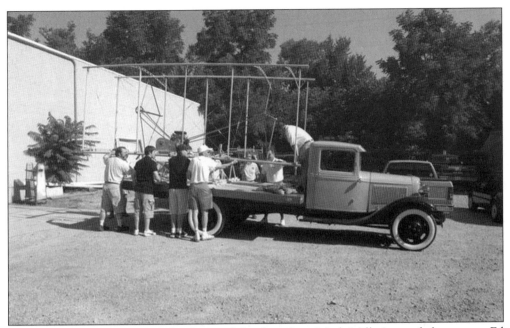

A crew of volunteers loaded the frame of the flyer from Mark Miller's wood shop on to Ed Meyer's 1933 restored Ford truck. They then took it to Packer Wings hanger at Clow International Airport in Bolingbrook for final assembly and testing. (PE)

After loading, the frame was driven through downtown Naperville on its way to the airport to generate as much enthusiasm as possible for the flyer and later flight. Penny Rusch, director of marketing at Packer Engineering, is shown here wearing World War II goggles and jacket and a silk scarf as part of the publicity. Dashing, indeed! (PE)

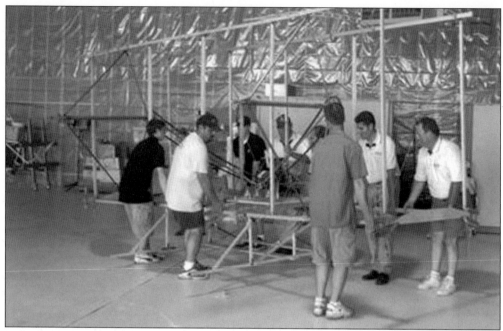

After driving the flyer from Miller's woodworking shop, Tom Norton and Mark Miller, working with other volunteers, lifted the frame from the truck bed, moved it into the hanger, and set it gently on the floor for final assembly and testing. Last stop is the Museum of Science and Industry. (PE)

Jean Mumford sewed together the panels of muslin fabric to cover the wings on her dining room table. All in all, 160 feet of fabric went into the flyer. Ted Kraft is shown stitching the wing panels together by looping heavy linen thread through the cloth and wooden structures and then tying knots, all on the same side of the wing, to keep the work symmetrical. (PE)

Volunteer Turk Tilev is balanced on a ladder as he adjusts the propeller drive tube assembly in this photo. Turk, once described as "a back yard rocket scientist," was one of the volunteers who could make small gadgetry or weld or do any other task that needed to be done. (CC)

Ted Kraft is on his back explaining to Turk, Ron Meyers, and his son Andrew the principles behind putting the propeller on a flyer 100 years ago as he checks the alignment of the propellers. The two propellers are driven off the same engine to create equal torque and they rotate in opposite directions to cancel out the torque and make the plane fly in a straight line. (CC)

Each summer, the Packer Foundation teaches interns various facets of the engineering business. In 2002, John Nowicki worked with interns to set up a company within the company to produce an engine from the Wright plans. The first task of the interns was to familiarize themselves with the drawings then compute the dimensions and tolerances for the various parts of the engine since the original plans only gave the sizes and shapes. (PE)

The interns went to the American Foundry Society to learn how to make castings in the old fashioned way. Here we see, from left to right, Kyioshi Martinez, Jamey Fenski, and Patrick McCormick making the molds for the metal castings. They first had to make a wood pattern, and then pack sand saturated with glue around it, let it harden, and finally remove the pattern to complete the mold. (PE)

Intern Katherine Korinek is making "gating and risering," which is the term used when a pathway for molten material to flow to the mold of the combustion chamber is made. You can see the pattern in the middle of the tray here. (PE)

Intern Jeff Ball is shown here working on a shaper mill to fabricate the crankshaft for the engine. The crankshaft was fabricated out of a 160-pound solid plate of steel. The plate was drilled out, put in a shaper (shown above), run through the horizontal mill, finished on a lathe, put first into a surface grinder, and then a journal grinder. When finished, the crankshaft weighed only 22 pounds. (PE)

Here is the finished crankshaft that Jeff was working on under the mentorship of Dave Bowman. This one-piece crankshaft will go in the four-cylinder, aluminum block engine that will also have cast iron pistons and sleeves. In 1903, aluminum was only 14 years old. Charles Taylor, the mechanic who worked with the Wright brothers, was really ahead of his time when he fabricated his engine using only a lather, a homemade drill press, and hand tools. (PE)

Kyioshi Martinez, on the right, is pouring hot molten metal into the molds with Matt Jacobs of the American Foundry Society, on the left. Foundry man Bogdan Perkowski is watching their progress. The metal must be about 2,600 degrees to pour and the mold was left to cool for 12 hours before unmolding. The part would still be hot—between 200 and 500 degrees. (PE)

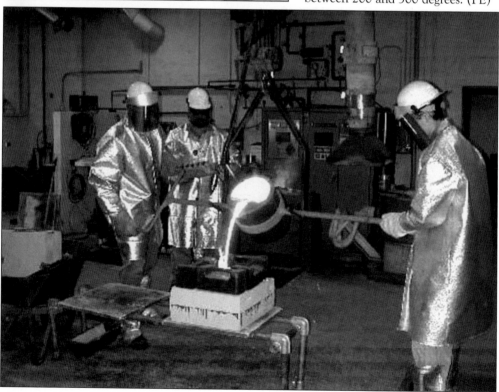

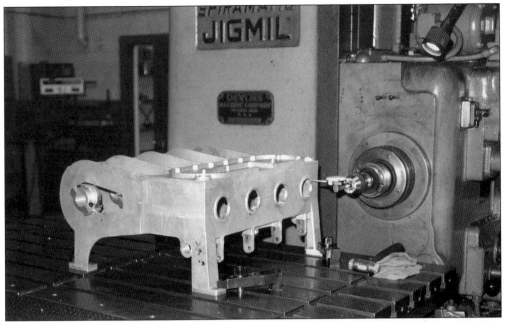

After Packer Technologies made three-dimensional drawings from the Smithsonian drawings, the Austin Group in Quincy, Illinois made a foam core which is a modern day advancement over the wooden pattern method. Willard Industries of Cincinnati, Ohio poured two aluminum castings. The Wright engine was an 11 horsepower, water-cooled, gasoline powered, four-stoke, four cylinder, internal combustion engine. (PE)

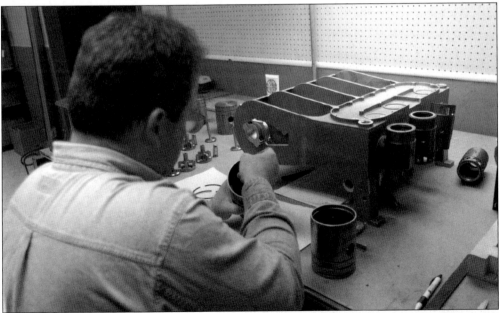

After the engine parts were molded, they were machined by taking rough castings and smoothing the parts so they would fit together. John Nowicki is putting the parts together to make sure that all the parts fit, and beginning the assembly and fitting of pistons and cylinders in the engine. The assembly took six, 60-hour weeks to complete. (PE)

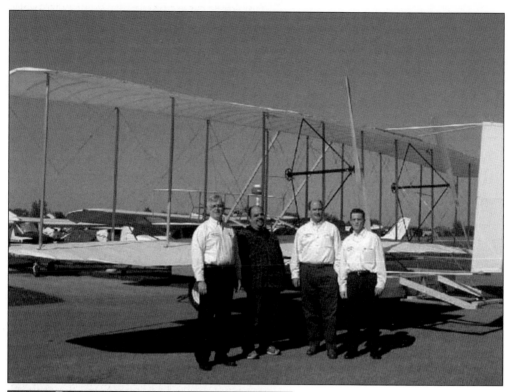

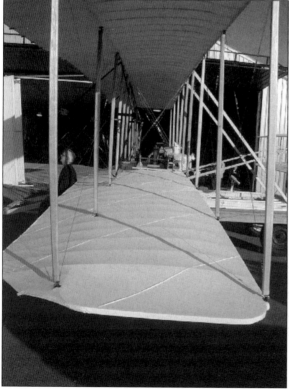

The Wright Redux group of, from left to right, Ted Kraft, Mark Miller, Mike Perry, and Chuck Clendenin inspected the flyer in September of 2002, when the flyer was ready for flight testing. Because there was only one, the flyer was attached to an old farm trailer, which was towed up and down the runway while the pilots got comfortable with maneuvering it. The trailer took the place of a wind tunnel. (PE)

After the flight, Ted Kraft thinks back on the preflight procedures of making sure that all the fabric was tight, that everything was safety wired, that all nuts and bolts were on, and the plane was ready to fly. The first tow was only about 10 mph so the pilot could get the feel of the flyer. By the fourth time, the flyer lifted off at 26 to 28 mph. (CC)

Two pilots were trained to fly the *Spirit of Glen Ellyn*. One was Ken Kirinzic, who took the flyer on the first test run, and the other was Mike Gillian. Ken, shown here, is making last minute adjustments as part of preflight testing. The pilots had to be less than 5 foot 8 because their feet are close to the engine and they have to be the same weight as the engine–150 pounds. (CC)

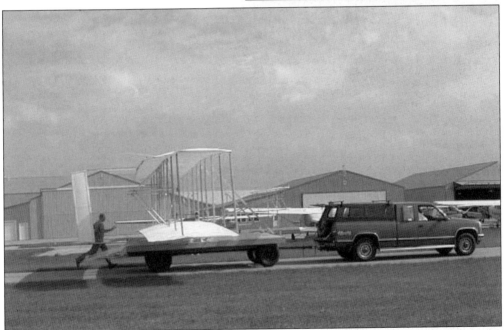

The first test run is shown here. Mike Perry is running behind the flyer, and Dr. Packer is driving the truck. On the fourth run, the flyer was able to lift off above the trailer. This photo is reminiscent of a photo of Wilbur Wright running along side the original flyer. (CC)

This photograph shows the flyer as it strains at the bungee cords and achieves lift! It soared one foot off the trailer. Of the several groups building replicas in the United States, the Wright Redux group was the first to get the flyer into the air. If you look carefully, you will see the sand bags instead of a pilot. (CC)

After the flight, pilots talk about the experience and almost always use their hands to "talk" as John Nowicki is doing here. John Nowicki Jr. (left) and Mark Miller (right) are listening as John (center) explains how it lifted off from the trailer concluding with, "The plane flew beautifully, nice and stable." (CC)

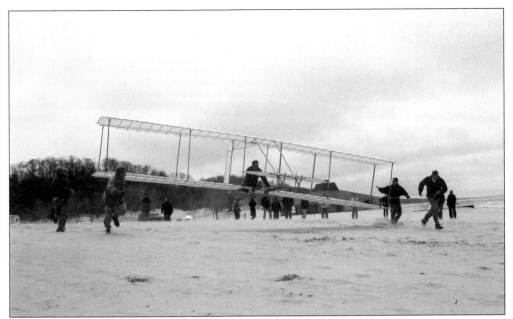

After the flyer was built, several pilots flocked to the Warren Dunes in Michigan to learn how to fly gliders, just as followers of Octave Chanute and the Wright brothers did 100 years ago. The two *Spirit* pilots could feel what it would be like once they were in the air. The gliders used were built from Wright plans for their 1901 and 1902 gliders. (PE)

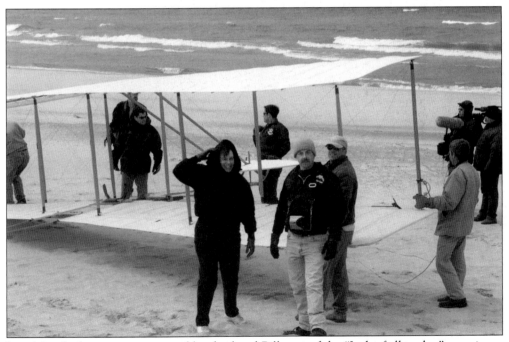

Jean Mumford, our seamstress, and her husband Bill, one of the "Jack of all trades," were in on the glider training. Bill lent his expertise in woodworking and metalworking for the *Spirit of Glen Ellyn*. Even after airplanes came into use, gliders were still used for fun and even in warfare. England used them to silently attack the Germans in World War II. (PE)

After the FAA inspected the builder's log, the blue prints and the flyer, they issued an airworthiness certificate on March 15, 2003. This FAA certificate was the first issued under the new standards for aircraft such as the Wright flyer that were eligible to be certified as "experimental for exhibition aircraft." A happy Mark Miller is holding the certificate. History Channel personnel were on hand to record the historic event. (CC)

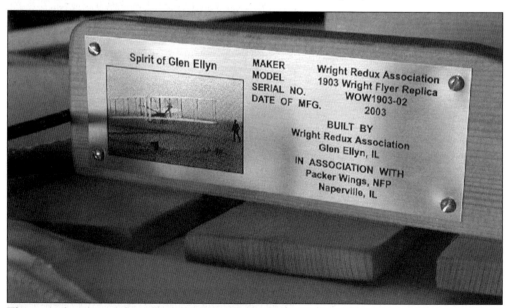

This is a close up of data plate installed on the flyer. The serial number, WOW, stands for Wilbur and Orville Wright and the number 1903-02 means that the *Spirit of Glen Ellyn* was the first replica to be certified. The Wright brothers held certificate serial number 1. After tail numbers N203WF were affixed, the flyer was ready for flight. (CC)

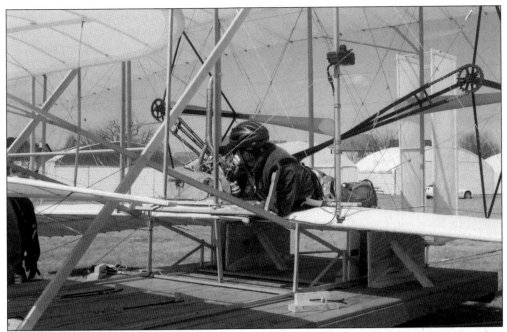

Ken Kirinzic is in position. The pilot controls the flyer by shifting his hips left or right within the cradle (seat), which causes wing warping. This is similar to the purpose of an aileron on the modern day plane. The control stick is directly in front of him. Look at how close the propellers are to his feet. (PE)

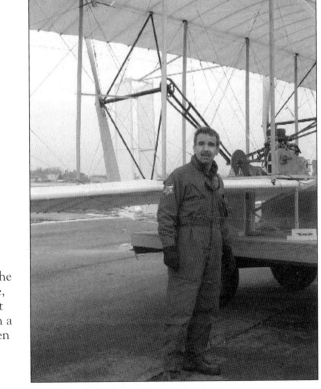

This first lift off with a pilot in position was February 1, 2003. "The plane flies great!" exclaimed Mike, who was wearing his "lucky" flight suit that day. He was able to fly in a crosswind without any trouble. Ken didn't have a lucky suit, but he always wore a hat when on the flyer. (CC)

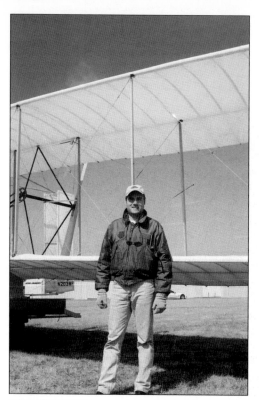

Steve Meyers, director of aerospace at Packer Engineering, functioned as the flight test engineer. He developed the protocol that was used in the flyer performance tests. He also oversaw the development of flight parameters, which determined that the best speed for successful flight was between 22 and 32 mph. (PE)

After the triumphs on the trailer, there were a couple of minor nicks and bruises. Mark Miller is gluing the skid back together with Gorilla Glue, his favorite formula, in this photo. Skids were added to the bottom of the wing tips to protect them during the test flights. (CC)

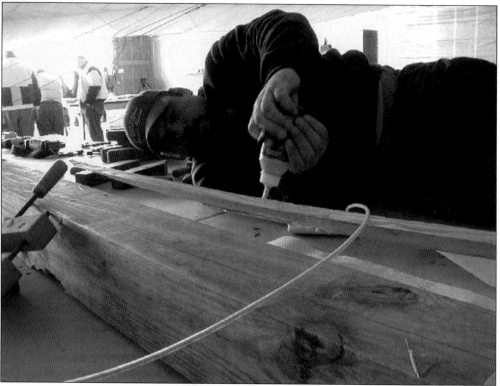

Mike Perry is checking the wind speed before he gives the go ahead for take off. He was looking for a gentle, 11 mph head wind for a successful flight. Perry used hand held anemometers—a digital in his right hand and analog in his left. The analog anemometer will be mounted on the flyer. (CC)

On April 27, 2003, the wind was right, and the pilots were trained. It was time to take off. The wind was only about 15 mph that day compared to the 25 mph wind the Wrights had during their first attempt. The flyer was mounted on a 120-foot rail just like the one that the Wrights used. The flyer accelerates down the rail and at the end it takes off! (CC)

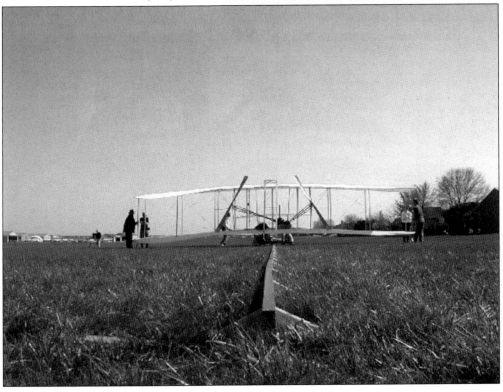

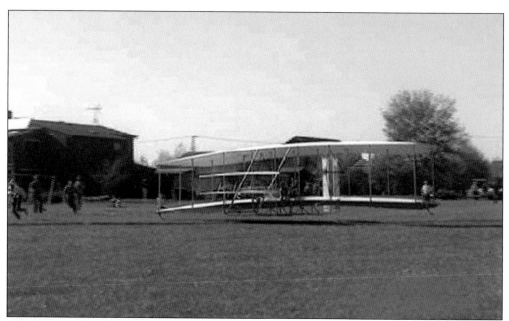

The *Spirit of Glen Ellyn* goes down the rail system and lifts off! The flyer flew between 18 and 24 inches off the ground for a distance of 140 feet; about 20 feet farther than the Wright flew. The pilot was Ken Kirinzic. The Wright brothers used a photograph showing a shadow similar to the one here to substantiate their claim to flight. (History Channel.)

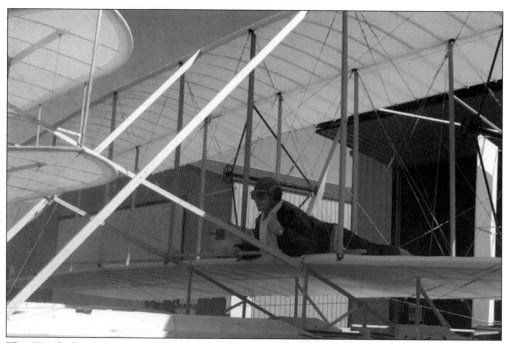

The Wright brothers were really ahead of their time. Instead of having nano technology and advanced materials to work with, all they had was fabric and wood. Working with those materials, they laid the foundation for many principles that are still cutting edge today. Chuck Clendenin is shown here getting a view from the pilots perch. (PE)

INDEX